The Land of the Sultans

AN ILLUSTRATED HISTORY OF MALAYSIA

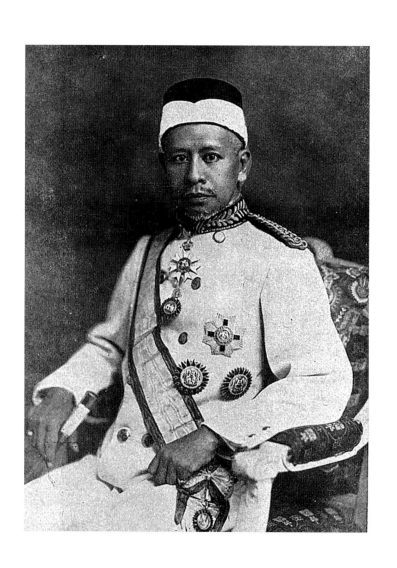

The Land of the Sultans

AN ILLUSTRATED HISTORY OF MALAYSIA

Ruud Spruit

THE PEPIN PRESS

AMSTERDAM AND KUALA LUMPUR

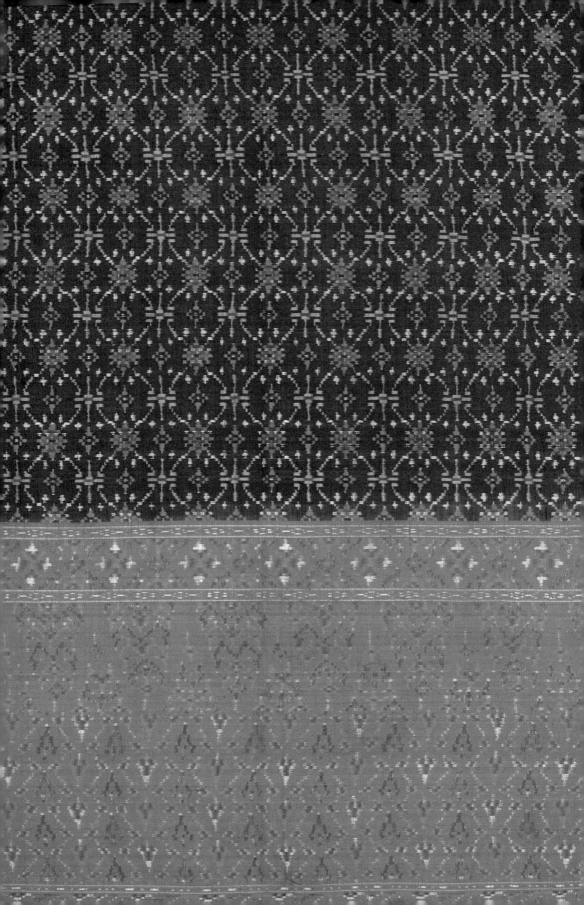

© 1995 The Pepin Press BV, Amsterdam
© 1989 original Dutch text Ruud Spruit

ISBN 90-5496-015-9

A CIP record for this book is available from the publisher and from the Royal Dutch Library, The Hague.

This book is edited, designed and produced by
The Pepin Press, Amsterdam and Kuala Lumpur
Printed in Singapore
Translation: Robert Lankamp

The Pepin Press
P.O. Box 10349
1001 EH Amsterdam
The Netherlands
Fax (+) 31 20 4201152

On the front cover: A Royal Malay kris with *jawi* (Malay in Arabic script) inscription.
On the back cover: Battle between Dayaks and James Brooke's men in Sarawak.
Page 2: Portrait of Sultan Zainal Abidin III, Sultan of Terengganu from 1881 to 1918.
Previous pages: 19th century textiles from Terengganu. The cloth on the right bears Islamic text in *jawi* script.

Contents

Map of South-east Asia *8-9*

Introduction 11

Malay Chronicles 15

The Portuguese 39

The arrival of the Dutch 53

The Dutch East India Company (VOC) in Malacca 69

The British 97

Malaysia on the road to independence 135

Picture credits *144*

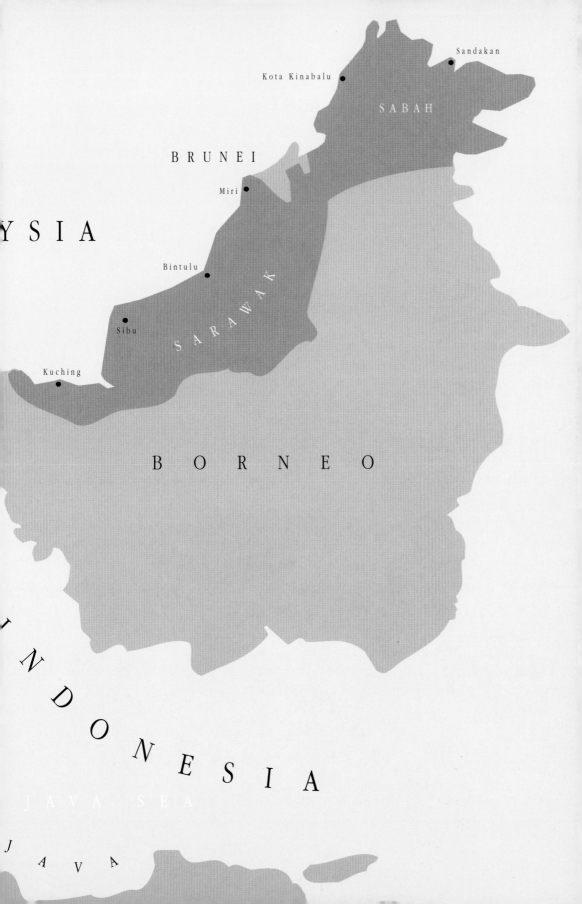

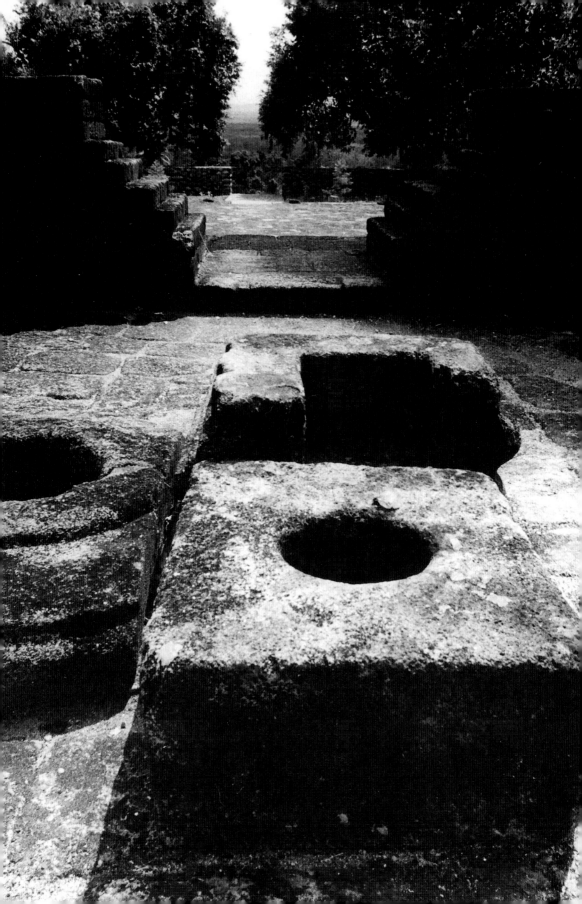

Introduction

Evidence of human habitation in Malaysia dates back thousands of years. Excavations on the peninsula have produced finds indicating crude stone age civilizations from between 8.000 and 2.500 BC, and early farm settlements between 2.500 and 500 BC. A bronze age civilization must have existed from the fifth century BC up to the second century AD.

It is known that in the early centuries AD there were regular contacts with the Indian sub-continent, and that there were a number of Indian states on the Malay Peninsula and the larger islands that are now part of Indonesia. The Indians introduced the Hindu and Buddhist religions to this region, and an early prominent Buddhist kingdom on the peninsula was that of Lankasuka in the north. Temple remains from this period have been discovered in the Bujang Valley in Kedah, and various other sites in Kedah and Perak.

From the seventh century, much of the peninsula probably came under some form of influence of the great Hindu-Buddhist empire of Srivijaya, which was founded in Palembang on Sumatra. At its height — in the 12th century — Srivijaya controlled all of Sumatra, the Malay Peninsula, the greater part of Java, and many other islands in the region. In the 13th century the Srivijaya empire was succeeded by the kingdom of Majapahit, which had its principal seat on Java, and exerted its power over an even larger territory, including parts of Borneo. Srivijaya and Majapahit had much in common, including family links between its rulers and a form of Hindu-Buddhism which was blended with ancient South-east Asian customs and traditions, differing from region to region.

Left: Temple remains from the Hindu-Buddhist period in Bujang Valley, Kedah.

11

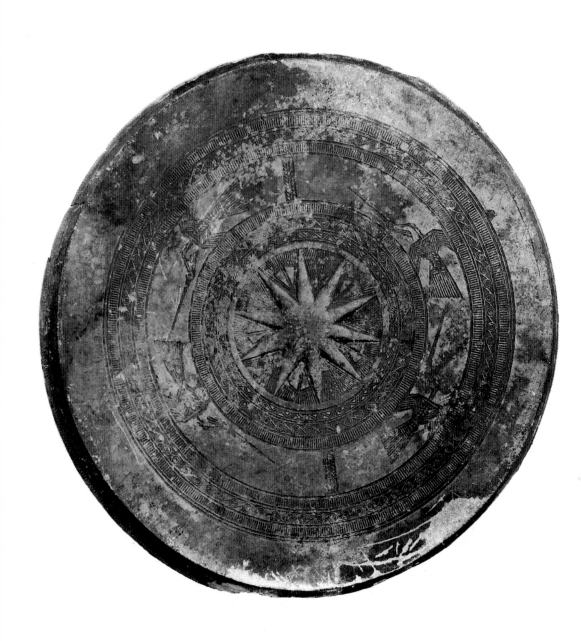

All this time South-east Asia had been increasing its economic strength, and at the time of Majapahit there was extensive trade with India, Indo-China and China. The states of the peninsula, although under the authority of the Hindu-Buddhist empires, had enjoyed a high degree of independence.

In the 14th century another powerful state emerged in the region, rivalling the might of Majapahit: Sukhotai in Siam. It may have been destined that the peninsula would succumb to either of these, but instead something else happened. The peninsula became the location of the most powerful state of its time in South-east Asia, and it is here that the story of Malaysia really begins: the Sultanate of Malacca.

Left: Drum head from the bronze age, found in Selangor.
Below: The earliest surviving mosque in Malaysia, built in Kelantan in the 16th century.

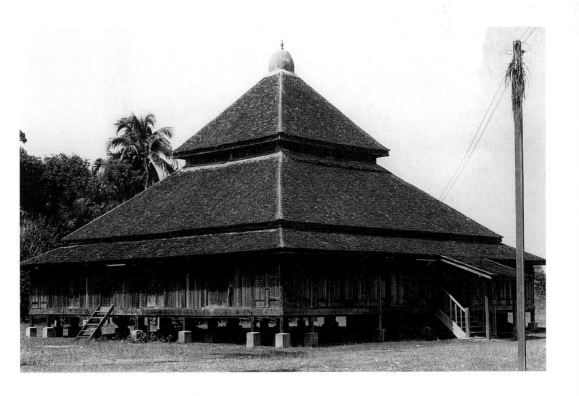

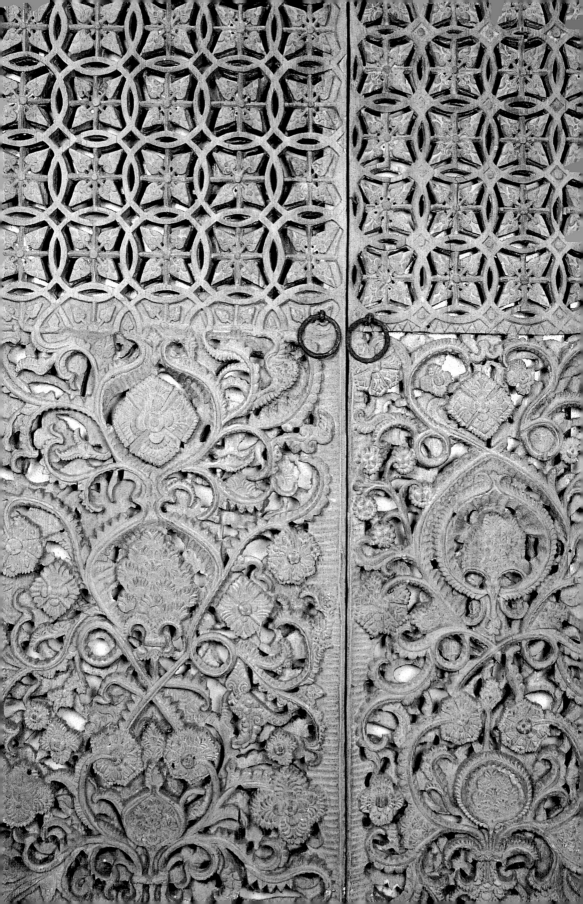

Malay Chronicles

The City of the Kantjil

Long ago Rajah Iskander Shah, who was descended from
Alexander the Great, ruled over the state of Singapore. Iskander
had comely wives and graceful children. When he saw how extra-
ordinarily beautiful the daughter of his *bendahara* (highest civil
servant) was, he took her into his harem. That made the other
wives jealous. They spoke so much evil about the girl that
Iskander had her impaled at a corner of the bazaar. The *benda-
hara* was enraged about the dishonour done to his daughter. He
sent a message to the king of the powerful Javanese realm of
Majapahit that the time had now come to conquer Singapore —
he would betray the city. The King of Majapahit sent a fleet of
three hundred large, and innumerable small, ships carrying no
less than 200,000 men. The battle began. Iskander asked his *ben-
dahara* for rice for his soldiers, but the latter refused. 'There is
no more rice', he lied to his sovereign. At dawn the keeper of the
treasury opened the city gate and let in the Javanese. A terrible
massacre ensued, and even today Singaporeans show tourists the
red stains on the Padang, the main boulevard, which are said to
be a blood from that massacre. Iskander fled. The *bendahara*
fared badly. Divine wrath descended upon the traitor. His supply
of rice turned to dirt and he and his wife became stones which
can still be seen in the moat of Singapore.

Iskander first journeyed to Muar, but there he was set upon by
large iguanas. His men killed so many of the giant lizards that the
carcasses spread a noxious stink. The place is still called Biawak
Busok, the stinking iguana. Iskander journeyed on and arrived at
a coastal place. While he was resting in the shade of a tree he

Left: Carved wooden door with a
geometrical pattern on the upper
part. The design of the lower part
is based on a flowering tree.

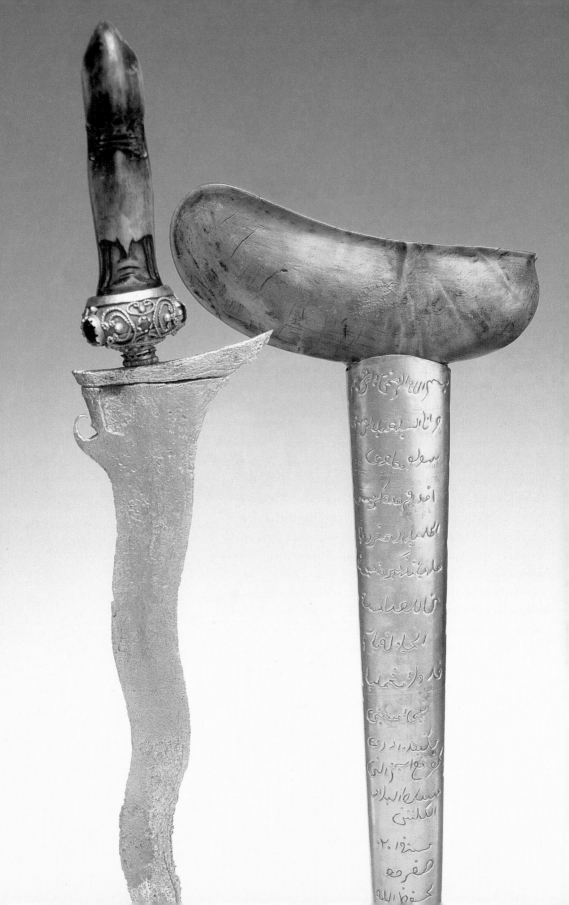

saw his dog being attacked by a *kantjil* (mouse deer). The miniature deer gave the dog such a kick with its hoofs that the dog tumbled into the water. Iskander thought, this is a good place. Here even the *kantjil* has strength and courage. Here I will build a city. He called the place Malacca, because the tree under which he was resting was a malacca tree.

Above: A *kantjil* or mouse deer.

Parameswara

This is how the history of Malaya begins as it is described in the *Sejarah Malayu*, the important Chronicle of the Malays. It is a chronicle with no dates. Some researchers believe that the text dates from the Portuguese period, others claim that the work was commissioned by Sultan Abdullah of Malacca, who is said to have reigned from 1610 to 1621. A comparison of Javanese chronicles, Siamese texts and Chinese encyclopedias led Western historians to an unclear figure with the title of Parameswara (prince consort) as the originator of the earliest history of Malacca. He was said to have been a prince from the city of Palembang in South Sumatra who, after marrying a princess from the powerful Javanese kingdom of Majapahit, had amassed enough power to take possession of the strategically important island of Tumasek (present-day Singapore). Knowing that after this impulsive act he would fall afoul of mighty Siam, which laid claim to all of the Malay Peninsula, the prince journeyed north and settled in what is now Malacca. Its favourable location and Parameswara's profitable alliances, including China and the Arab world, led to great prosperity for Malacca.

The *Sejarah Malayu* by no means describes these events in the Western manner. While a large number of facts corresponds to the results of academic research, the chronicle also abounds in poetic license meant to glorify sovereign and people and good relations with the gods. It is a chronicle where, for example, Parameswara as a matter of course becomes Iskander, descendant of Alexander the Great, the forefather of many who play important roles in oriental chronicles.

The wordplay and solemnity of the language may have been lost in translation and summary, but readers willing to be enthraled by the tales of this chronicle receive an impression of a fairytale oriental world of centuries ago, in which totally different values were the norm. Although often supplemented, the chronicle is the

Left: A golden kris and sheath with Islamic inscriptions.

17

main source for this history up to the arrival of the Portuguese.

The Introduction of Islam

One of the descendants of Iskander was Raja Kechil Besar. One night this ruler of Malacca dreamed that he was visited by the prophet. 'Your name will be Sultan Mohammed', the prophet said. 'Tomorrow a ship will arrive from Jeddah. The crew will disembark to pray. Do what they tell you.' When Raja Kechil awoke the next morning he noticed the odour of nard on his body and that he had been circumcised. He got up and continuously repeated the profession of the faith in Arabic, the language of the prophet. His wives thought that their lord had gone mad and called for the *bendahara*. The prince recounted what had happened to him. The *bendahara* decided to wait for the ship from Jeddah, because its arrival would prove that Raja Kechil was not possessed of the devil. At sunset a ship from Jeddah anchored off the coast. A gentleman disembarked so that he could pray on dry land.

Below: Arab seafarers.

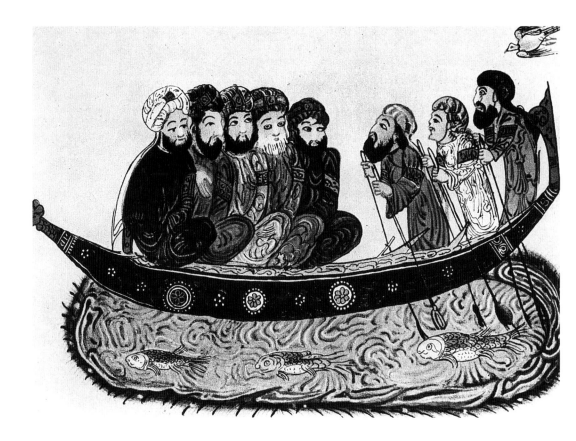

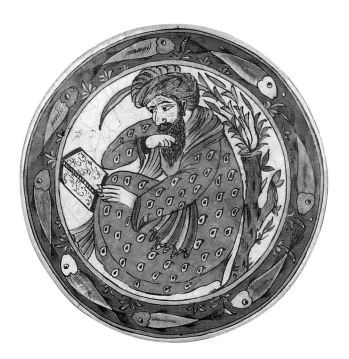

Above: A Persian tile showing an Islamic scholar.

Amazed, the people streamed out of the city to the beach to see what was happening. Rajah Kechil rode to the beach on his elephant and invited the stranger to his palace. The prince and all his subjects then became muslims, and Rajah Kechil called himself Sultan Mohammed Shah.

While this narrative is a poetic description of the coming of Islam and claims it occurred under sultan Mohammed, other sources state that the Hindu prince known as Parameswara was the first convert to Islam. The connection with Islam, which was expanding through Asia, was of great importance to Malacca. The harbour became a familiar place for Arab merchants, who brought a selection of goods from the west which could be traded in Malacca for oriental wares. Malacca became a significant trade centre. Climatological factors made it impossible to voyage directly from east to west. One part of the year the south-easterly monsoon brought ships from the east. They departed on the southwesterly monsoon which prevailed in another part of the year and which, in turn, brought ships from the west.

The First Koran Lesson

When a child becomes six or seven it is brought to a teacher for its first Koran lesson. The child arrives, bathed and dressed in traditional Malay clothes. The young pupil carries the Muquaddam *(the book of the first thirty verses of the Koran), a half bottle of lamp oil, a rotan stick, rice, bananas, some* sirih *and a* ringgit *note. Often the first Koran lesson is celebrated with a simple feast.*

19

Above: Two boys engaged in a silat performance.

Nobles and Commoners

Prior to the time of the sultans, the communities on the Malay Peninsula were closed and largely self-sufficient. Only surplus produce was traded among neighbouring *kampongs* (villages) by means of the rivers. The legal system was laid down in the *adat perpateh*, a matriarchal system originating from Sumatra, in which a man belonged to his mother's clan up to his marriage and to his wife's clan afterwards. Land passed from mother to daughter. Under the *adat* customs, the community was responsible to a high degree for the errors of an individual, and group restitution of damages were the rule rather than individual punishment.

Mass migrations and invasions from surrounding countries caused the kampongs to seek each others' support; this resulted in increasing power for the chiefs and in the institution of a military. This state of affairs was ideally conducive to the introduction of feudalism, which coincided with the rise of Malacca. Within a short time a class of nobles headed by the sultan had come into being. The sultan possessed absolute power and literally had the power of life and death. Surrounded by rituals and tribute, he would be an exemplary and almost divine ruler to his subjects. A basic principle of Malay law may be found in the *Sejarah Malayu*: the sultan will defile no subject's honour and only administer capital punishment when the crime is punishable by death according to divine law; a subject may in no way turn against his sovereign. Daily life was regulated in detail. For example, during the reign of Mohammed Shah it was decreed that yellow was the royal colour. No one else was allowed to use yellow. Also, rules were laid down prohibiting farmers from decorating their houses and from wearing other clothes than the simple sarong and head-cloth. Golden ankle bands were the reserved for female royalty. The sultan was assisted by the *bendahara*, the highest civil servant with the powers of a viceroy. The sultan and the nobility, who were often interrelated, presented a closed front to the outside world, but internally there would often be power struggles. Many nobles had independent positions, especially the chiefs of remote districts. The sultan and the nobility strove to achieve a balance between absolute power and the loyalty of the populace, on whom they were dependent for food and warriors. The nobility replaced the *adat perpateh* by the *adat temenggong* which strengthened the position of the nobility, for example by inheri-

tance along the male line and a deterrent penal code with personal convictions and a system of fines payable to the lord.

Threat from Siam

The growth of Malacca did not go unnoticed. When the *bunbunnya*, lord of Siam, heard that Malacca was a prosperous state outside his domain, he sent an ambassador. The ambassador conveyed a demand for a letter of tribute to the *bunbunnya*. Sultan Muzaffer Shah of Malacca refused, knowing that such a letter meant subjugation to Siam. The results were not long in coming. The enraged *bunbunnya* equipped a large army. Muzaffer called up all able-bodied men in the wide surroundings of Malacca. Headman Tun Perak from the district of Klang also came. He not only brought warriors but also their wives and children. An adviser of the sultan's asked Tun Perak what this meant. Tun Perak had the question repeated three times and then calmly spoke: 'His Majesty is here in Malacca with women and children and everything he has. When the women and children of my men are also in Malacca, they will not only fight for the sultan, but also for their own families.' The sultan thought this showed such great wisdom that he sent Tun Perak *sirih* from his own box.

The Siamese army was thrown back. Its soldiers fled in disarray. The rattan with which they bound their possessions they threw away at Muar, along with the blocks of fig wood to which prisoners were tied. The rattan and fig wood took root and still grow there. The sultan kept Tun Perak in Malacca and made him *bendahara*.

A second attack from Siam, this time carried out by a fleet, also failed. When it approached Malacca in the evening the *bendahara* had lights hung in the tops of the mangroves and other trees. The Siamese believed that a gigantic fleet was waiting for them and fled to Singapore, pursued by Malaccan ships. Again a fleet was equipped, now under the leadership of Chau Pandan, the aggressive son of the *bunbunnya* of Siam. When news of the fleet reached the palace of the Sultan of Malacca, Sidi Arab happened to be there, an Arab who was an extremely proficient archer. Sidi Arab moved in front of the sultan and shot an arrow in the direction of Siam. 'Die, Chau Pandan', he called out. The sultan laughed and said, 'If Chau Pandan really dies it is proof of supernatural power'. At that moment Chau Pandan felt a fierce pain, as

Silat

Legend has it that the Malay martial sport silat was introduced in the wake of Islam. This extremely elegant means of self-defence was taught to boys after lessons in the Koran. Silat probably originated in North Sumatra. One legend holds three boys from the Minangkabau faithfully attended their Koran lessons. Their teacher's house was close to a waterfall. One day Amiruddin, one of the three, went to the river to bathe and fetch water. A flower of the bongor tree fell and danced lightly on the wavelets of the foaming water. The blossom repeatedly drifted to the edge of the waterfall, but would be thrown back onto the wavelets by the water splashing up. For half an hour Amiruddin watched the tender blossom which by twisting and turning withstood the enormous power of the water. Finally the boy scooped the blossom out of the water and it was as if the bongor tree told him how to make use of the lesson of the flower. Silat, which consists of dancelike movements which prevent attackers from grasping their victims, was born.

if he had been hit by an arrow. Blood streamed from his mouth and he fell dead to the ground. The voyage to Malacca was postponed.

The sultan had had enough of the continuous threat from Siam. He decided to send an embassy to try to form an alliance. A letter was carefully composed which was sent by elephant from the palace to the Siamese fleet to the accompaniment of music. The *bunbunnya* received the envoys and read the letter. 'Why have we never conquered your city?' he asked. The ambassador had an old man brought up who suffered from elephantiasis. The man threw a spear high in the air and caught it on his back. The spear glanced off his hard skin and fell to the ground. 'All Malaccans are like that', the ambassador said. The *bunbunnya* was amazed and an alliance was formed between Malacca and Siam.

Ceremonies

One element in the tale of Tun Perak and the *bunbunnya* of Siam is oriental homage. As a proof of extraordinary gratitude the sultan sent Tun Perak *sirih* from his own box. The use of *sirih* is said to have originated in Malaya. A chewable *sirih* consisted of sliced betel nut and *gambir*, rolled in a lime-coated betel leaf. Chewing *sirih* was a popular custom, and a fixed part of many events. A boy would be given *sirih* against the pain of circumcision. The go-between for a proposal of marriage would be received with *sirih* in the girl's family's house. Betel leaves and nuts were carried in the procession which preceded the planting of rice, and betelnut tongs were laid on corpses to ward off evil. The boxes carrying the ingredients varied, depending on the status of the owner, from simple to very luxurious. The Sultans of Malacca kept a precise list of who was entitled to receive *sirih* from the sultan's box.

Another form of homage was expressed in sending or receiving a letter. Because it was generally impossible for a sultan to make a long and dangerous journey to meet an ally, letters would be ceremonially delivered instead. These letters were composed with great care and after extensive consultation. When completed, the letter would be sent to a ready ship by elephant to the accompaniment of music, and would be received in the same way at its destination. The addressee would carefully listen to how the letter was worded and would inquire extensively as to the manner in

which it was sent. After the envoys returned, the sender of the
letter had them tell him how the letter had been received. Some
sultans put so much effort into sending their letters that the
addressee, learning that, would be very flattered. But, often
enough, some impoliteness in the phrasing or some carelessness
in the sending of a letter resulted in war. Such letters were seen
as a challenge.

Above: A *sirih* box.

Envoys from China

During the reign of Sultan Mansur Shah, word of the fame of Malacca reached the Chinese imperial court. The emperor sent an embassy to Malacca with a gift consisting of silk and brocade and also a load of nails. The accompanying letter stated that the houses in China were innumerable and that was why the emperor had sent along as many nails as there were houses. Sultan Mansur Shah smiled. He sent an embassy to the emperor, led by his youngest brother Tun Parapateh Puteh. The gift included a load of sago. 'Tell the emperor that my subjects are more numerous than the grains of sago that I have sent', the sultan ordered. Tun Parapateh was deeply impressed by the Forbidden City. The enormous square where the imperial audiences took place was full of officers, civil servants and courtiers, whose numbers greatly surpassed the sultan's greatest audiences. Tun Parapateh had the presence of mind to convey his brother's message. He flattered the eunuchs by regaling them richly with the costly rings he wore on each of his fingers. In this way he became a popular guest. The emperor was impressed by the tales he heard about Malacca and offered his daughter Hang Li Po in marriage to the sultan. Tun Parapateh gratefully accepted and apologized for his brother who could not come himself because of the many enemies surrounding him. Hang Li Po travelled back with the Malays, accompanied by 500 lackeys and ladies-in-waiting. She married the sultan and received a hill near the palace as her own property. This hill, *Bukit Cina* (Chinese Hill), is still cherished by the Chinese in Malacca and for centuries it is where they have buried their dead. The sultan sent his father-in-law a letter of acclamation. After the emperor had read the letter he fell ill, his body was covered with white spots. The court doctors were at their wits' end. According to legend, the only remedy was water in which the sultan had washed his feet. The water was fetched with a fast ship. The emperor drank it, bathed in it and promptly recovered. After that no more letters were exchanged between the two monarchs, but the friendship between the Emperors of China and the Sultans of Malacca continued for a long time and many Chinese settled in the peninsula.

Below: Chinese ceramic incense burner with Islamic inscription. Items such as this were made specially for export to Muslim nations.

Cheng Ho

The above lyrical narrative about the first contacts between China
and Malacca has its more factual and dated counterpart in the
Chinese imperial encyclopedias. Viewed from that source, the nar-
rative acquires a more credible political background. The events
in question occurred during the reign of the Ming emperor Yung
Lo (1403 to 1424). In that time China had become isolated
because of continuing Mongol incursions: the traditional silk and
spice routes over land, along which Marco Polo had travelled to
China in the 13th century, had become insecure and disused. This
caused stagnation of exports to the Arab world. Simultaneously,
the expansion of Siam was an increasing threat. The Chinese
empire needed alternative routes to Arabia, and also wished to
form alliances with other powers threatened by Siam. The most
obvious option was to make use of maritime routes, which natu-
rally led through the Malay archipelago and the Straits of Malacca.
Enormous fleets were equipped, led by the Chinese muslim Cheng
Ho. This admiral made five voyages with fleets which could con-
sist of dozens of junks and crews of more than 25,000. These
fleets even sailed as far as the African east coast, where the
Chinese very nearly encountered the Portuguese, who at that time
were also venturing further from home.

In Malacca Cheng Ho is still honoured in a temple at the foot of
Bukit Cina. Of course a Cheng Ho legend is told in Malacca:
The admiral's ship sprang a leak as a result of a terrible storm.
The water poured in. Cheng Ho prayed to the god of the sea, and
the leak repaired itself immediately. Upon arrival in Malacca, it
appeared that a *Sam Po* fish had stuck itself into the hole. Cheng
Ho carefully removed the fish which was still alive and set it free.
The *Sam Po* fish still occurs abundantly in the Straits of Malacca.
The fish has spots on both its sides and it is said that these are
Cheng Ho's fingerprints.

Hang Tuah and Hang Jebat

The following tales are of Malay popular heroes who are still hon-
oured today. The most famous of these heroes are Hang Tuah and
his friends, including Hang Jebat, Hang Kasturi and Hang Nadim.
As young men they were sent by the sultan with a fleet of five
hundred ships to see whether the daughter of the King of
Majapahit was really as beautiful as was rumoured. There are

numerous tales of their stay in Java in which, time and again, the Malays outsmarted the Javanese.

One day Hang Jebat and Hang Kasturi decided to sit at forbidden places in the audience room of the palace. They had hardly sat down when the palace guard was upon them with lowered lances. But Hang Jebat and Hang Kasturi lightning-quick cut off the points of the lances with their swords. When the king came to investigate the commotion and saw what had happened, he ordered his guards to leave the two fighters from Malacca alone. From then on at each audience the two sat at places of honour near the king. In the meantime, Hang Tuah was so popular in Java that all the women were talking about him. They sang songs about him and even disengaged themselves from their husbands' embrace when the hero went past.

The King of Majapahit was so impressed by the Sultan of Malacca that he decided to accept him as his son-in-law. A feast was laid on that lasted forty days and forty nights. The guests were uninterruptedly amused with food, drink and *gamelan* music, *wayang* plays and dances.

A Legendary Battle

At one time the popular hero Hang Tuah had risen to *laksamana* (admiral). Intrigue and slander, however, resulted in Hang Tuah's fall. The sultan, swayed by all the defamation, ordered his *bendahara* to have the *laksamana* executed. The *bendahara* understood was what really happening. He knew that his lord would regret the deed, hid Hang Tuah in the mountains, sending his clothes dipped in goat's blood to the sultan as proof of his death by execution. The *laksamana* was replaced by his friend Hang Jebat. But Hang Jebat was not proof against all the luxury his new rank entailed. He could not keep his hands off the ladies in waiting and the sultan's concubines and in the end he forced the sultan out of his own castle.

The sultan came to regret his order to have Hang Tuah executed. The *bendahara* thought the time was ripe to tell him that Hang Tuah was still alive. A solemn and moving reunion followed. Hang Tuah approached his master with ceremony and respect, formally dressed in a gold embroidered *tengkolok* (hat), a belt wound seven times inscribed with verses from the koran, a green sarong, a red vest and the kris *Parang Sari*. After the reconcilia-

tion, the people of Malacca gathered around, convinced that the moment had come that Hang Tuah would kill his former friend Hang Jebat. Hang Tuah went to the palace where Hang Jebat lived. Hang Tuah waited until the hottest part of the day, when everyone within the palace would take a nap. Then Hang Tuah came nearer with his soldiers. The people of Malacca climbed into trees and onto rooftops to miss nothing of the spectacle. The clatter of weapons woke everyone in the palace. The women ran around in fright. Hang Jebat got up, surprised. 'Come outside, rebel', Hang Tuah called. Jebat stood as nailed to the ground when he recognized the voice of his friend, thought to be dead. Confused, he shook his head, bathed in the golden bath and put on clean clothes. Then he opened the palace gate. 'Come outside Jebat', Hang Tuah called again. 'Who can you be', Jebat called, 'Hang Tuah is dead'. 'I am not dead', Hang Tuah answered. 'The *bendahara* hid me and now I have come to punish you. Show remorse'. 'I am not sorry', Hang Jebat called, 'I'll come out to fight you but first I have to sharpen my kris and eat'.

Hang Jebat retreated into the palace and locked its forty doors. Then with his own hand he killed the seven hundred women in the palace. The blood poured over the galleries and dripped through the floor boards. Horror-stricken, the people of Malacca watched. When Hang Jebat finally opened a door, a violent fight followed. When the fight moved inside, the soldiers stormed under the building and shoved their lances through the floor boards. 'Stop that', Hang Tuah shouted, 'you will wound me too'. The soldiers retreated. The two combatants became tired. 'Let us sit down on large dishes so that they can't wound us through the floor', Hang Jebat breathed. The two men sat. 'It seems you really want to kill me', Hang Jebat said. Hang Tuah nodded. Then both men burst into tears, understanding that this was inevitable.

'Listen', Hang Jebat said, 'I will die without children, but one of the *bendahara's* ladies-in-waiting is seven months pregnant with my child. If it is a son, let your son take him into his service. If it is a girl, let the mother decide.' Hang Tuah promised and the fight started again. After a long fight, Hang Tuah suddenly plunged his kris deep into Hang Jebat's chest. The blood splattered everywhere and the wounded man collapsed.

Hang Tuah sheathed his kris and walked out of the palace, and went to his house where he hid in its darkest room. Curious, the

spectators came out of the trees and off the rooftops and crept nearer. Hang Jebat was still alive. He had stopped the bleeding with a cloth and rose up with a shout when the spectators crept into the palace. Panicked, they fled, tumbling over one another, rolling down the steps and breaking legs and noses. Some even fell onto their own weapons and lay dead in front of the palace. The wounded Hang Jebat stormed outside. Wildly he brandished his sword and killed many Malaccans. Everywhere there were the bodies of men, women and children. Panicked, people attempted to flee the city to nearby kampongs but there too Hang Jebat continued his murderous spree. Finally the sultan sent a messenger to Hang Tuah's house to tell him what was happening. The messenger told Hang Tuah about the terrible massacre. Hang Tuah went outside and found Hang Jebat. 'Enough is enough, Jebat, you have killed hundreds of people. Now you yourself must die.' Hang Jebat walked up to Hang Tuah, gave the official salute and followed him to his house. Hang Tuah wiped the blood off his friend's body and had rice and *sirih* brought in. 'Don't forget to care for my child', Hang Jebat said. Hang Tuah promised with tears in his eyes that the child would be as his own son. Then Hang Jebat asked Hang Tuah to loosen his bandages. Hang Tuah carefully loosened the cloth. The blood spouted and Hang Jebat died in the arms of *laksamana* Hang Tuah.

Prosperity and Riches

The sultan no longer wished to reside in the palace where the drama with Hang Jebat had occurred. He ordered his *bendahara* to have a brand-new palace built. It became a building like none that had been seen before in Malacca. It was a building with 17 colonnades. Every column was so wide that a grown man could hardly embrace it. The roof consisted of seven floors and was crowned with a spire of red glass. The walls of the palace were covered with mirrors. The forty doors were all gilded. The roof was covered with copper and tin plates. The sultan and his court had barely moved into the brand-new palace when a fierce fire broke out. However, within a month a new palace had been built that even surpassed the earlier one in splendour.

Such extravagance was possible because Malacca's reputation as a safe and busy harbour attracted increasing numbers of merchants. The money poured in. Not everyone was proof against all these

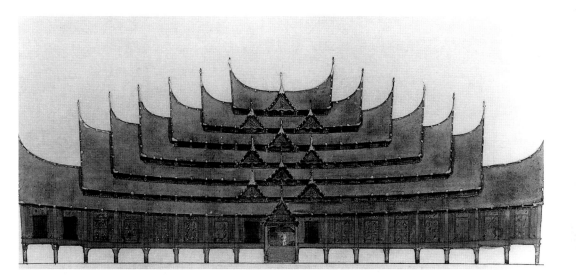

riches according to tales of decadence and degeneration at the
court. Raja Mohammed, a son of the sultan's, became terribly
angry when his turban was accidentally knocked off by the son of
the *bendahara* during a game. The servants carrying the *sirih*
box, seeing the prince's anger, killed the *bendahara's* son on the
spot. Enraged, the boy's family had a meeting. The *bendahara*
said: 'Be calm, a Malay does not get excited about things like this.
But we will never call that prince our master.' The Sultan of
Malacca punished his son by sending him to the state of Pahang
on the east coast of the Malay Peninsula, and having him crowned
sultan there.

Above: Reconstruction drawing of
Sultan Mansur Shah's palace, built
in about 1460.

Merchants and Scholars

The prosperity of Malacca allowed for the teaching of philosophy
and theology, as is evident from the arrival of the Arab Islamic
scholar Abu Kabar in Malacca who achieved fame with his Koran
teachings. As a centre of trade, Malacca prided itself on being a
city where the merchants could feel secure with their money and
goods. At night the city was carefully guarded, so that theft was
rare. Sometimes, however, vigilance weakened as happened dur-
ing the reign of Sultan Alauddin. There were complaints about
thieves and the sultan decided to investigate for himself.
Disguised as a thief, the sultan went out with two companions. In
the dark they ran into five thieves who where dragging off some
chests. The sultan and his helpers killed three thieves, the other

two escaped. The next day the chief of police was summoned. The sultan showed him the dead thieves and their booty. The chief of police was terribly shocked and promised improvement. From then on there were strong patrols once again in the streets at night. Burglars and thieves were killed on the spot. One time a thief was caught while burgling a shop, and his arm was cut off with so much force that it lodged in the wall, hand and all. The next morning the shopkeeper got the shock of his life when he made the discovery.

The Promised Bride

At the sultan's court one had to be mindful of one's words and this is evident from a tale about the daughter of Seri Nara Diraja, a noble at the court of Sultan Mahmud. During a visit to Malacca by Pateh Adam, the *pangeran* (ruler) of Surabaya, the Nara Diraja's two-year old stepdaughter Tun Manda toddled to the *pangeran* and babbled something to him. 'I do believe she is proposing to you', Nara Diraja joked. 'I accept', the Javanese prince said. Then he bought a slave child in Malacca which he took to Java and raised there. The growing girl reminded him constantly of Tun Manda. When the little slave had reached marriageable age, Pateh Adam thought it was time to return to Malacca to collect the girl that he thought had been promised to him. He journeyed to see Seri Nara Diraja with forty nobles and a great show of warriors to keep Nara Diraja to his promise. The latter remembered nothing and said it had only been a joke. Furious, Pateh Adam left the palace. He asked where the girl lived and decided to abduct her. He succeeded in getting hold of her, but a violent fight broke out, and it only ended when Pateh Adam, holding his kris to the girl, threatened to kill her if he could not keep her. Seri Nara Diraja decided to let Pateh Adam go. The two married and, satisfied, the *pangeran* returned to Surabaya with the wife he had won.

Dangerous Desire

The moral of a tale about Sultan Mahmud is that a sultan does not always get what he wants. Sultan Mahmud's wife had passed away and he grieved deeply. He called in his *bendahara* and other advisers. They said they would bring in any princess the sultan wished. The sultan shook his head, because those were princesses

any ruler could get. He wished for an extraordinary woman, someone like the wondrous princess living on the Gunung Ledang, a high mountain in the state of Johor. Two of the most distinguished court nobles went to the mountain. They were accompanied by Tun Mahmut, the liege of Johor. Halfway up the mountain, the two nobles were unable to continue and Tun Mahmut, accompanied by a few strong men, climbed to the summit. The wind blew harder. The clouds scudded around the mountain. The wind blew so hard into a bamboo organ that the birds fell silent and curious animals came to listen.

Finally Tun Mahmut arrived in a wonderfully beautiful garden where the flowers whispered poetry to each other and the birds sang without cease. In the middle of the garden there was a pavilion of human bones with a roof of human hair. In it sat a noble old lady and four young girls. The lady asked Tun Mahmut why he had come. 'I serve the princess of Gunung Ledang' she said, after Tun Mahmut had told his tale. 'I will convey the sultan's wish to my mistress'. The lady and her servants disappeared and returned a short while later. 'Tell the sultan that the princess agrees to marry him', she said to Tun Mahmut. 'But as a dowry he is to provide a gold bridge and a silver bridge from Malacca to Gunung Ledang, seven dishes of mosquito livers, seven dishes of louse livers, a large flask filled with tears, a large flask of juice from young betelnuts, a bowl of the sultan's blood and a bowl of his sons' blood.' Tun Mahmut came down the mountain and the sultan was told about the dowry. 'She can get all she asks for', the sultan said, 'except the blood.' And he cancelled his marriage plans.

Cotton

Sometimes in the Malay court chronicles, information can be found about the products that were traded, as for example Indian and Ceylon cotton cloth. Hang Nadim was sent by his master Sultan Mahmud to the Realm of the *Kling* (Ceylon). His assignment was to buy forty pieces of cotton cloth, each of a single type of cotton. The ruler of the *Kling* immediately had five hundred artisans called in to draw patterns for the cloths. But none of these patterns pleased Hang Nadim. Finally, to the amazement of the Ceylonese draughtsmen, he made some sketches himself. Immediately, these designs were executed by the astounded arti-

sans. They praised the artistry of the noble from Malacca.

The cotton of this tale was bought at the behest of the Sultan of Malacca. He and all of the local nobility intensively took part in trade. For the most part, other business in Malacca was in the hands of foreign merchants, mostly from Java, China, South India, Gujerat, Burma and Arabia. These foreign merchants lived together in separate parts of the city. They elected representatives — the *shah bandars* — who had a say in the government of Malacca. It was in the sultans' interest that the merchants felt at home in their harbour and could count on being treated well. There was also a board of merchants who decided the value of all goods shipped in, on which a tax of sic to seven per cent was levied.

By such means Malacca attracted merchants from India to Japan with their shiploads of silk, silver, salt, rice, camphor, opium, gems, sandalwood, slaves and other wares. Also, the ships needed to pass the Straits of Malacca or else make a long and dangerous detour. The changing monsoons kept the seafarers from going from Arabia or India to China in a single voyage; whether travelling east or west, in most cases ships would have to wait for a favourable wind and anchor at Malacca.

Tun Teja

The states with which Malacca traded were either subject or allied states. One way to cement an alliance was by marriage. The Malay chronicles are full of romantic tales of beautiful princesses from faraway kingdoms. The inhabitants of Merlimau, just outside Malacca, still lovingly care for the mausoleum of Tun Teja, in the middle of the *kampong*. Tun Teja was the daughter of the *bendahara* of Pahang. Word of her beauty reached Malacca and Sultan Mahmud. The sultan could think of nothing else; his desire for this unknown woman grew by the day. Finally he sent Hang Nadim to Pahang to try to abduct Tun Teja. Nadim befriended a certain Said Ahmad and stayed in his house. After a long search, he found an old lady who massaged girls; Tun Teja was one of her clients. Nadim bribed the old woman, told her of his plans and gave her a love potion which she was to rub on Tun Teja's skin. The old woman went to work and also told Tun Teja that she was too beautiful for the Sultan of Pahang. Tun Teja became

increasingly curious and in the end everything culminated in a meticulously planned abduction. Furious, the Sultan of Pahang pursued them, but he was driven back by a deluge of arrows. Frustrated, the Sultan of Pahang turned back and rammed his own audience room with his elephant, shouting that he would do the same with the palace of Sultan Mahmud in Malacca. In the meantime, Sultan Mahmud had taken Tun Teja into his palace, to the satisfaction of both. When he heard about the Sultan of Pahang's threat, he asked for a volunteer to abduct the sultan's elephant. Admiral Khoya Hassan offered his services. He voyaged to Pahang with an extremely polite and apologetic letter. In the meantime he became good friends with the caretaker of the elephants and went to the river at the time the elephants took their baths, so that the animals grew familiar with him. When the moment of departure had come Khoya Hassan said his ceremonial farewells, after which he took his ship to the river and waited until the elephants came. With the help of the keepers the sultan's elephant was brought aboard. When he heard, the Sultan of Pahang nearly choked with rage. He abdicated in favour of his brother and went up the Pahang river, where he spent the rest of his life meditating in solitude. Sultan Mahmud lived happily with his wife until he was driven away by the Portuguese. Tun Teja followed her husband in his flight but she died along the way and was buried at Merlimau.

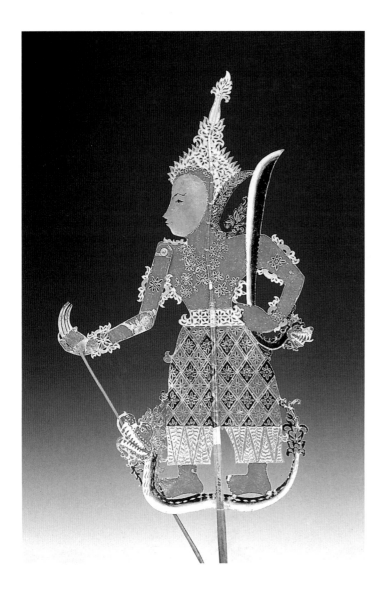

Above: A *wayang kulit*.

Wayang Kulit

For centuries the grand epics *Mahabharata* and *Ramayana* have been providing the narratives for *wayang kulit* (literally 'leather puppet'). They spread across Java, Thailand, Cambodia, and the Malay Peninsula, developing local forms which sometimes influenced each other. Originally the performance had a magic and religious significance. The silhouettes represent the ancestors who are summoned by the *dalang* (puppeteer), who acts as a medium between mortals and the gods. In bygone centuries, Malay sultans enjoyed performances with enormous complex silhouettes created

by dancers behind huge screens. But for ordinary people, the most common form of shadow play employed eighty centimetre dolls behind a three to four metre wide screen. Especially, in the northern Malay state of Kelantan *wayang kulit* attained great refinement. The occasion for a performance might be a marriage, a circumcision or a harvest feast. The *dalang* builds a hut on stilts, with the screen at the front and the other three sides closed off with mats. The *dalang* selects a part from the *Ramayana* which can fill three consecutive evenings. After evening prayers, the wayang performance is announced with percussion instruments which may be heard for kilometres around. An apprentice holds a prologue after which the *dalang* begins the real performance. He sits behind a lamp which can be gently swung back and forth for effects. Behind the *dalang* sits a small orchestra. With a rattle laying next to him the *dalang* signals when the orchestra can emphasize moments of high tension or the end of a dialogue. A good player can enthral his audience by weaving all sorts of local situations into the performance, while the comical characters serve to break the tension with their jokes and gossip.

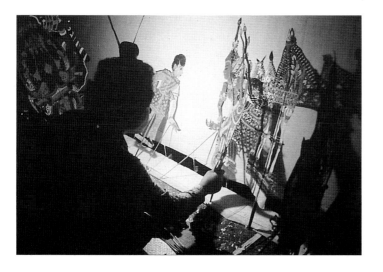

Left: A *dalang* performing a *wayang kulit* show.

Flying Kites

A favourite pastime in the time of the sultans was constructing and flying kites, according to a tradition which continues today in the Malaysian states of Kelantan and Terengganu. Originally it was thought that kites were a way to contact the wind and air spirits, so kites were made as beautifully as possible. Making kites was not child's play. The time after the rice harvest was deemed eminently suitable for making kites, a job that could take weeks. There were competitions for the most beautiful or fastest kite, or the best-sounding kite — some types of kite were provided with a taut bowstring which made a buzzing or screeching sound. It is said that an army commander who was surrounded by the enemy ordered his men to let up dozens of kites at night. The fearful sound that came screeching out of the dark sky frightened the enemy and they fled. A more poetic tale is the one about the young prince who floated on a golden kite to a fairytale princess in a palace high above the clouds.

Raja Ahmed, the Sultan of Malacca's son, had the habit of scouring through the lines of other kites with the line of his own big kite so that his kite would finally dominate the sky. The clever Hang Isah Pantas hit on the idea of making a small fast kite; he coated its line with resin and pulled it through powdered glass. To his amazement Raja Ahmad saw a small impertinent kite rub against his line. The line broke and the large kite of the sultan's little son tumbled down.

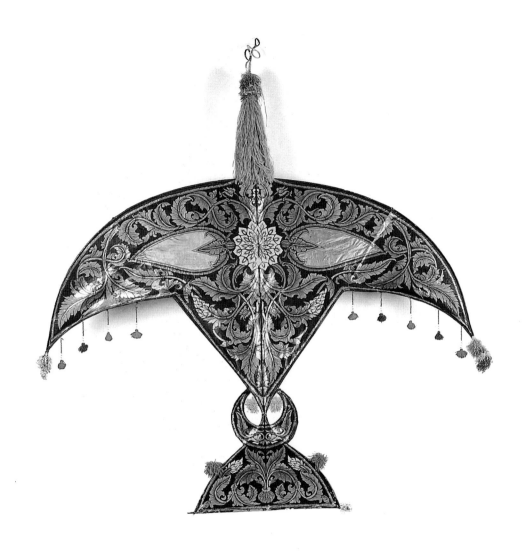

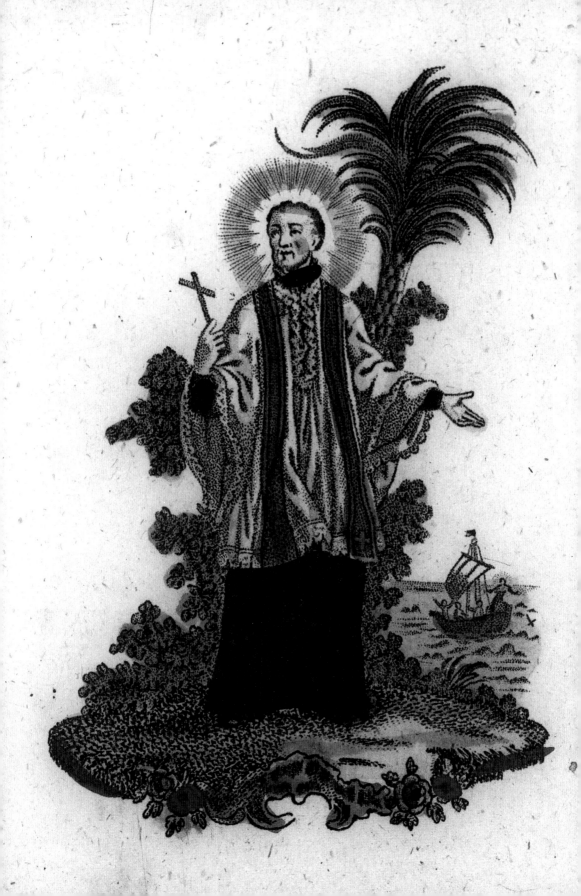

The Portuguese

Spices

Suddenly the Portuguese appear in the court chronicles: the sultan's beloved wife Tun Teja dies during her flight from the Portuguese. The arrival of the Portuguese was a decisive factor in Malayan history.

The rise of Portugal to a world power able to penetrate deep into Asia had been a process lasting hundreds of years. It began with the struggle between Islam and Christianity in Europe. From the 8th century onwards, Arab influence had spread over the Iberian peninsula to the foot of the Pyrenees. Arab mathematics, geography, literature and other scholarly pursuits spread from Moorish cities like Cordoba to the European universities. This influence lasted centuries after Islam had been slowly but surely driven first southwards, and then out of the Iberian peninsula altogether.

Christian kings distributed the lands conquered from the Arabs among their feudal vassals. Portugal came into existence as a county in the 11th century. Through fortuitous military victories, intrigue at the papal court and deft marriages, the succeeding counts were able to raise the country to the status of an independent kingdom. Portugal's favourable location, its agricultural surplus, its energetic urban population and its ambitious nobility contributed to the early establishment of commercial relations with England, the southern Netherlands, France and the countries of the Mediterranean.

But the Portuguese wanted more: they had their eyes on the lucrative spice trade. But here they ran into opposition from the Ottoman empire. After the fall of Constantinople in 1453, the

Left: St Francis Xavier 'the Apostle of the East'.

39

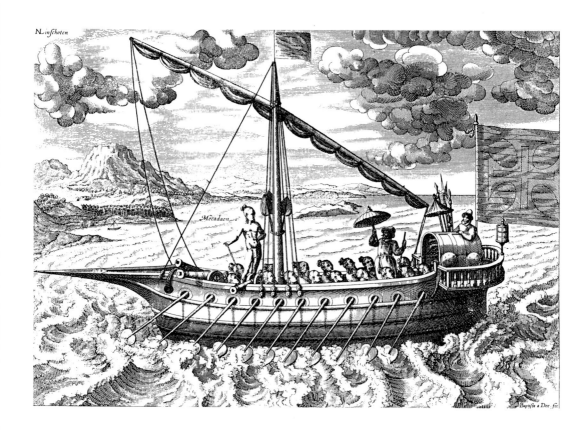

Above left: A Portuguese ship as used in South-east Asia.
Above right: Portuguese civilians in Malacca.
Both illustrations are from Jan Huygen van Linschoten's *Itinerario* (see next chapter).

power of the Ottoman empire spread rapidly across the Middle East. The trade in spices became an Ottoman monopoly; only Venice and Genoa were allowed to stockpile spices in Alexandria for trade with Europe. Backed by scions of the Portuguese royal dynasty such as Prince Henry the Navigator and Prince João, explorers like Bartholomew Diaz and Vasco da Gama discovered their own sea routes to Asia and thus to the spice trade. This was a slow process. The Portuguese developed the manoeuvrable caravel and the roomy caraque, both inspired by Arab ship design. Caraques were large enough to transport sufficient sailors, soldiers, provisions and, above all, cannon. It was mainly by means of cannon that little Portugal was able to subdue great Asian kingdoms.

For navigation, the compass was used. The compass was introduced by the Arabs but probably invented by the Chinese. Improved maps and itineraries enabled sailors to cover longer distances without having to keep land in view at all times. But above all, the Portuguese were driven by hunger for profit and adven-

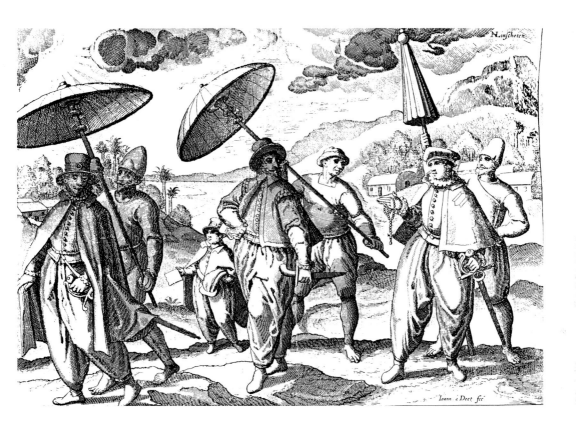

ture, and the urge to spread the Christian faith. In undertaking to lay hands on the spice trade, they not only risked serious conflict with unknown oriental potentates, but also the wrath of the entire muslim world, not to mention Venice and Genoa.

Colonization was not the issue. The Portuguese limited themselves to carting off the wealth of Africa. Local names that the Portuguese gave such as Costa do Marfim (Ivory Coast), Costa do Ouro (Gold Coast) and Costa dos Escravos (Slave Coast) speak for themselves. In 1488 Bartholomew Diaz rounded the Cape of Good Hope and the way to Asia lay open.

Thereafter, Portuguese fleets made further incursions into Asia. Tactics were always the same. The Portuguese would suddenly appear off a harbour city and would bombard it. The damage and the confusion would be such that the merchants would quickly agree to sell their wares for very reasonable prices. Soon the Portuguese began needing bases, preferably in places dominating important straits and trade routes. In 1502, Cochin, the prominent pepper port, was conquered. In 1506 Socotra, at the entrance to

the Red Sea, followed and in 1510, Goa on the West coast of India was taken. The Portuguese now looked forward to the possession of Malacca, the depot for spices and oriental goods.

The Fury of the Cannon

In 1509 a fleet under admiral De Sequeira sailed to make a first visit to Malacca. The Portuguese were received cordially. The inhabitants of Malacca crowded about to see the amazing ships and the 'white Indians'. In the Malaccan court chronicles we may read that the inhabitants pulled at the clothes of the Portuguese and fingered their beards. There was a moment of danger when De Sequeira, against oriental protocol, approached the *bendahara* to hang a gift gold chain around his neck. The *bendahara* quieted the furious crowd and said, 'Calm down, these people are not familiar with our customs'. The Portuguese enjoyed all forms of

Below: Afonso D'Albuquerque at the conquest of Malacca.

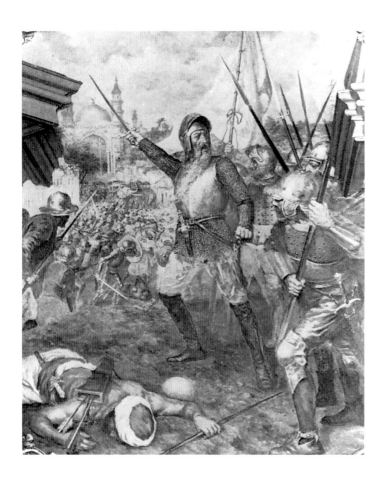

42

hospitality and were even allowed to do some trade. The merchants were not pleased. Especially the traders from India were suspicious: they had heard of what the Portuguese had done elsewhere and they feared the worst. After much discussion they managed to convince the *bendahara* to eject the Portuguese. The Portuguese were surprised by the sudden attack. With difficulty, De Sequeira brought three of his five ships to safety. A number of Portuguese did not manage to escape and were taken prisoner. When De Sequeira arrived in Goa, Afonso D'Albuquerque had been appointed its viceroy. D'Albuquerque understood that Malacca was more important and prosperous than had been previously thought. He used the attack on the Portuguese as a pretext to voyage to Malacca in 1511 with a superior force of ships, soldiers and Indian mercenaries. As usual, the Portuguese began with firing their cannon. The Malaccans were initially surprised at the unfamiliar thunder of cannon but panicked when they saw the destruction of life and property that the cannonballs caused. The Portuguese landed and a bitter battle followed, which mainly took place at the strategically important river bridge. The Malaccan army was led by Ahmad, Sultan Mahmud's son, who led his troops from his elephant. When evening fell, the battle was undecided. The Portuguese retreated to their ships. Ahmad and his men gathered at the sultan's palace. A storyteller was summoned, who at Ahmad's request told the story of the brave warrior Emir Hamzah to instil courage into his audience. D'Albuquerque did the same, in his own way. He gave a speech to his soldiers, saying that the conquest of Malacca was beneficial to Christianity, their king and Portuguese commerce.

After a pitched battle in which Malaccan spears and elephants were not able to stand up to Portuguese cannon and muskets, the city fell. The sultan and his sons fled to friendly neighbouring states. Afonso D'Albuquerque had his greatest wish fulfilled: Malacca was in Portuguese hands.

A Famosa

D'Albuquerque consolidated his new possession in two ways. He attempted to restore trade as quickly as possible and granted the Indian and Chinese merchants broad privileges to restore their confidence. The Portuguese were less affable towards the Islamic traders. The exclusion of the muslims from Malaccan trade did

D'Albuquerque on Malay Courtesy:

'The Malays are gallant and very courteous, they dress beautifully, and will permit no one to lay hands on their head or shoulders. They love talking about military affairs. No one except the sultan, or those who have especially received his permission to do so, may wear yellow. This is a capital offence.

When they speak to the sultan, the chiefs and nobles must keep a distance of five or six paces. Nobles who have been condemned to death have the privilege of dying by the kris — a close family member carries out the execution.'

Right: Potuguese coin used in
Malacca.

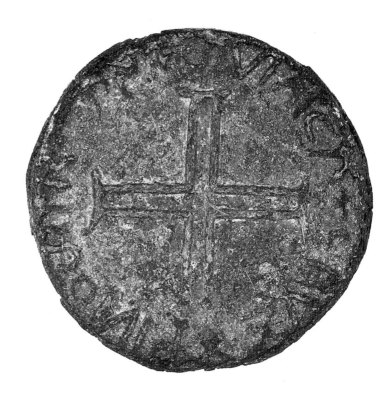

anything but strengthen the Portuguese position. On the advice of
Indian merchants, a new currency was introduced, consisting of
silver and copper coins. The new currency was announced by
means of an elephant parade, with the front elephant carrying the

Below: The only surviving
remains of the *A Famosa* fort.

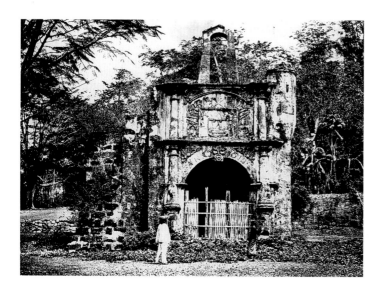

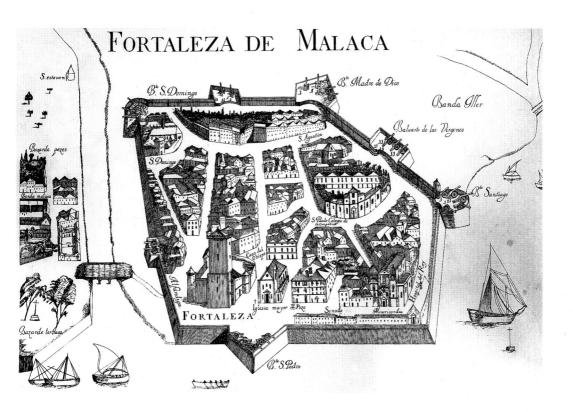

FORTALEZA DE MALACA

S. estevam

Bazarde pezes

Banda malaca

Bazarde turbas

B. *S. Domingo*

B. *Madre de Dios*

Banda Mer

S. Domingo

S. Agustin

Baluarte de las Virgenes

B. *Santiago*

S. Paulo Colegio de la Compañia

Casa del Obispo

A. Famosa

Iglesia mayor *Pozo*

Senado

Misericordia

Hospital del Rey

FORTALEZA

B. *S. Pedro*

Portuguese royal standard. Then there was an elephant with a
civil servant reciting the proclamation. The next two elephants
carried riders who tossed new coins to the crowd.
D'Albuquerque also created much new construction. He was
obliged to use slaves and mercenaries because most of the
Portuguese soldiers were sick with tropical illnesses. At the foot
of the hill a fort rose to protect the river. Its most striking feature
was a heavy square forty metre tower with cannon on each of its
four levels, and at all four sides. Laterite was used as a building
material, and egg white was one of the components used in the
mortar. The Malaccans were more than happy to supply laterite
and eggs against payment in the new currency. The fort was
named *A Famosa* (The Famous One) and D'Albuquerque had a
memorial stone set in the tower with the names of his lieutenants.
When disagreement arose about the order of the names,
D'Albuquerque promptly had the stone put in backwards. On the
visible side there was an allusion to the psalms: *Lapidem quem
reprobayerunt aedificantes* (the stone that was rejected by the
builders).

Above: Plan of the Portuguese
fortress in 1512.

On top of the hill a church, dedicated to Our Lady of Ascension, was built on the spot of the sultan's palace which the soldiers had destroyed. At the shore, a hospital was erected for the many ill. Around the settlement, a wall and fortifications were built of the same red laterite as the church and the tower. Construction was completed after a few months. Before returning to Goa, D'Albuquerque installed an administration consisting of a governor, assisted by a judge, a mayor and a bishop. There were also a captain for the troops and a public prosecutor. The traditional Malaccan offices of *bendahara*, *temenggong* and *shah bandar* were retained, as well as the 'capitans' (leaders) of the different population groups.

On the return voyage to Goa, D'Albuquerque was caught in a terrible storm where he lost his proud ship *Flor de La Mar*.

Afterwards it was said that the viceroy had hardly cared about the ship and its cargo but had put in much effort to bring to safety a 15-year old slave girl he had bought in Malacca.

After D'Albuquerque's departure, the reconstruction of Malacca

Below: Malacca in 1536.

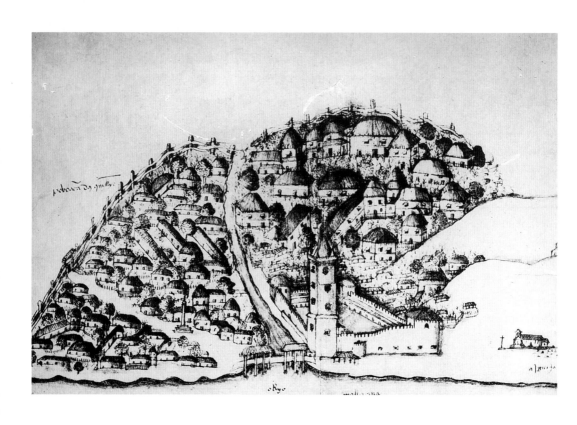

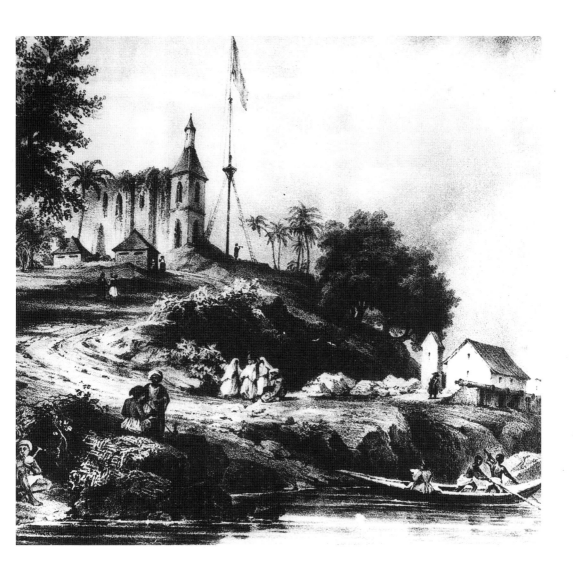

continued. Within the walls and fortifications, a Portuguese town arose with a handful of churches, a cathedral, palaces for the governor and the bishop, cloisters, chapels, a poorhouse and a second hospital. Malacca was destined to become the administrative and spiritual centre of the *Estado da India*.

Above: St Paul's church in Malacca, built in 1521. The remains of this church still stand.

Francis Xavier

Francis Xavier, a Basque born in 1506, was one of the first followers of Ignatius de Loyola, founder of the Society of Jesus, the later order of Jesuits. Xavier heeded King João III's appeal for six priests for Goa. Xavier travelled extensively through Asia and

stayed in Malacca a few months, caring for the ill, standing by the dying and teaching the Portuguese. The missionary was concerned with education; he succeeded in having the bishop of Goa found schools. A Father Perez and a Brother Oliveira were sent to Malacca to start a school. The two clergymen were given the old small church on the hill. They started a school with 180 students which would later become the premier Jesuit college in Asia. Xavier visited the school once or twice, voyaged to the Moluccas and Japan and died in 1552, on an island off the coast of China. His body was brought to Malacca, where in a candle-light procession it was brought to St Paul's church on the hill and interred. Three months later it was decided to move Xavier's body to Goa. The ship carrying the remains almost ran aground in bad weather, but a wondrous play of the wind blew the ship out of the danger zone. These were all factors leading to Xavier's canonization in 1621. He was a typical product of the counter-reformation, obsessed with spreading Roman Catholic Christendom.

Below: Drawing of a Malay ship, as used in Malacca during the Portuguese period.

Regrettably, the brilliant saint was succeeded by clergymen of a lower calibre who lacked understanding of other religions and

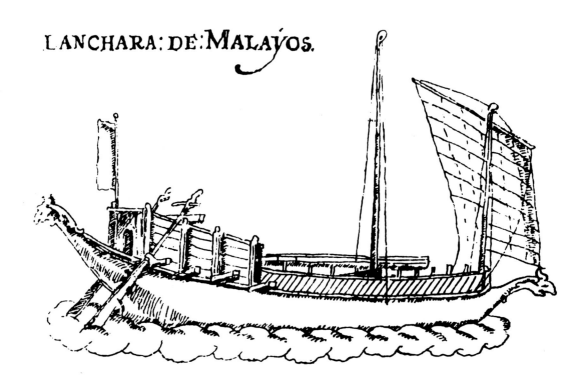

LANCHARA: DE: MALAYOS.

carried out, to the letter, decrees such as that of Philip II prohibiting non-Catholics from holding public office — including public office in the Asian possessions. In addition, in their hatred of Islam many clergymen sought to obstruct muslims in all possible ways. It is clear that this policy was not conducive to solid political and commercial relations between the Portuguese possessions and the other Asian nations.

Below: Gold coin from the Sultanate of Johore.

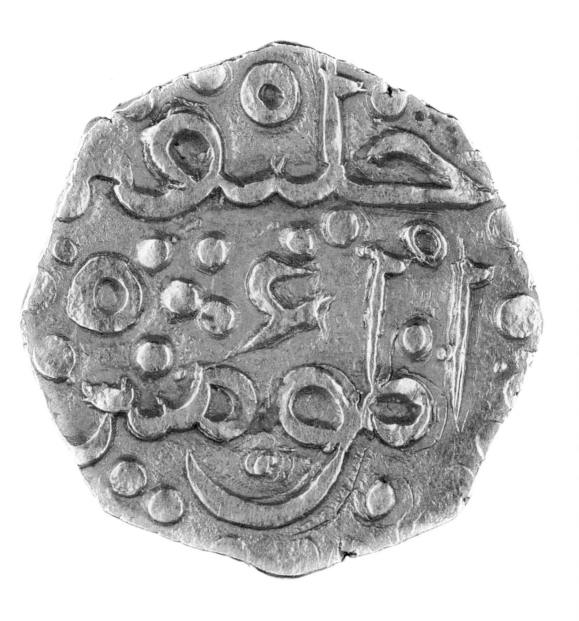

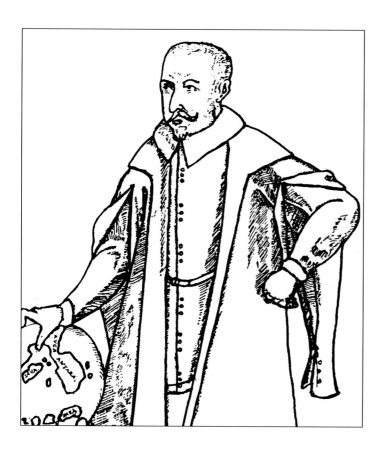

Above: Portrait of Admiral Manuel Godinho de Eredia, who was the son of a Portuguese naval officer and an Indonesian princess, and at one time cosmographer of Malacca.

Trade Monopolies

In the beginning, the Portuguese in Malacca succeeded in getting a grip on the spice trade. When Coromandel coast pepper became too expensive, pepper of at least equal quality was purchased in Java and Sumatra, and local merchants were cleverly played against each other. The Portuguese would acquire precious cloves from the Moluccas, by exploiting the perpetual conflict between the sultans of the North Moluccan islands of Ternate and Tidore. This required the permanent presence of a Portuguese fleet in Moluccan waters. Large fortunes were made from the trade between China and Japan: the Portuguese had succeeded in monopolizing the trade between these ancient enemies. The most important trade goods were silk from China and silver from Japan. During the heyday of Portuguese trade, a merchant could earn so much from a single Goa-Macao-Nagasaki voyage that for the rest of his life he and his family could easily live on those earnings. Meanwhile, the expelled Sultan of Malacca and his sons did

everything they could to regain their lost kingdom. After the fall of Malacca, Sultan Mahmud had moved his court to the island of Bintan, south of Singapore. From here the sultan repeatedly raised armies which put so much pressure on the Portuguese that they almost reconquered Malacca. Eventually, Mahmud's elder son settled in Perak where he assumed the name of Sultan Mudzaffar Shah. The establishment of this sultanate is the reason why today Malaccan titles are still in use in Perak.

The Portuguese boycott of muslim merchants in Malacca and the levy of duties from all ships passing the Straits of Malacca caused many merchants to look for other ports and trade routes. One port which soon benefited from this was Aceh in Northern Sumatra. Also, from here the Straits of Malacca could be avoided by sailing along the West coast of Sumatra. The Sultans of Aceh attempted to strengthen their position by time and again assaulting Malacca. Other rulers also took part. During a siege in 1586-1587 by the Javanese, the number of dead in Malacca rose to a hundred a day. The chronicles mention mothers throwing their dead children in the river.

The End of Portuguese Power

These attacks and the closing of the supply routes by the numerous enemies was an obstacle to further development of Malacca. Also, Portuguese colonization was a failure in the sense that the majority of Portuguese officials were nobles and court favourites, often lacking leadership qualities or economic sense. Mainly, the Portuguese in Malacca intended to make their fortunes as quickly as possible, as was expected of them by their families in Portugal. The gigantic profits which were made in spite of all the problems chiefly benefited the king, the church and the nobility. Instead of investing in ships, forts and other infrastructure, the money was used to build palaces and cathedrals. In addition, at this time Portugal was being threatened by Spain which had found the way to Asia by way of America, and backed by the papal Treaty of Tordesillas, Spain claimed the trade with China, Japan and the spice islands. When, after the union with Spain in 1580, Portugal was also dragged into the unwinnable religious war with the Netherlands, the end of Portuguese hegemony in Asia came into sight.

Loose Women

In his Itinerario *Jan Huyghen van Linschoten extensively described the licentiousness of the Portuguese women, who, while they were almost always confined to the house by their jealous husbands, nevertheless managed to arrange all kinds of adventures 'by night and bad weather, over walls, fences and roofs'. These lascivious women were always washing, used perfumes and aromatic herbs, chewed stimulating sirih, drank* arak *and reinforced their desires by eating pepper, cloves and ginger. They had an herb with which they could bring men into a sort of a laughing trance so that they could do with their victims what they wished.*

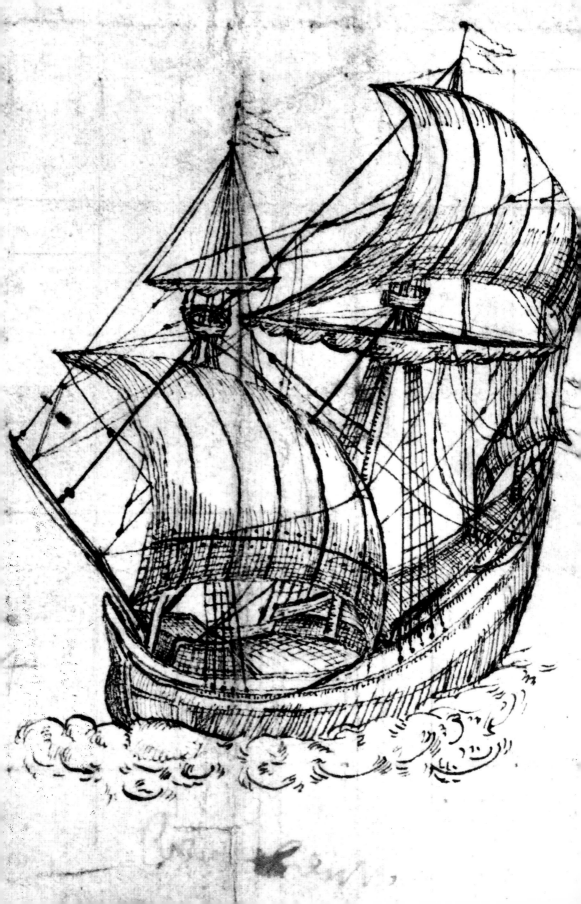

The Arrival
of the Dutch

A Sailor from Enkhuizen

While the Portuguese were gaining increasing knowledge of the
peoples and products of the Indies and the sea routes leading
there, Asia was still mostly unknown to the Dutch. Nevertheless,
Dutch interest in the spice islands was very much alive. While
few Dutch seafarers possessed maps or itineraries of the Orient,
seamen who had actually made the far voyages had gathered
much valuable information for eager Dutch audiences. Many
Dutch sailors made world voyages aboard Spanish or Portuguese
ships. In spite of the Eighty Years' War (the Dutch war of inde-
pendence against Spain), commerce between the two countries
bloomed, and many Dutchmen worked for or in Spain. But many
Dutch felt the time had come to make their own voyages to the
Indies. Towns like Enkhuizen and Hoorn supported the Prince of
Orange against Spain. After the Victory of Alkmaar and the Battle
of the Zuiderzee (the turning points of the war) the Spaniards
soon disappeared. Self-confidence had grown, as had the desire
to strike out over the Seven Seas with their own ships.

It was in Enkhuizen against this backdrop that Jan Huyghen van
Linschoten grew up, a boy 'liking to read about strange things
and tales from far lands, in which he had special interest'.

In 1579 he followed the example of his brothers and went to
Spain. He arrived in Seville at a time of many changes. King
Enrique had died without a successor; the Portuguese royal
dynasty was extinct. The war for the Portuguese crown was won
by Philip II, and this resulted in the union of Spain and Portugal.
At the same time Spain had been struck by a plague epidemic and
one of Jan Huyghen's brothers died. The other took him to

Left: Drawing of one af Admiral
Matelieff's ships involved in the
conflict with the Portuguese in
Malacca in 1606.

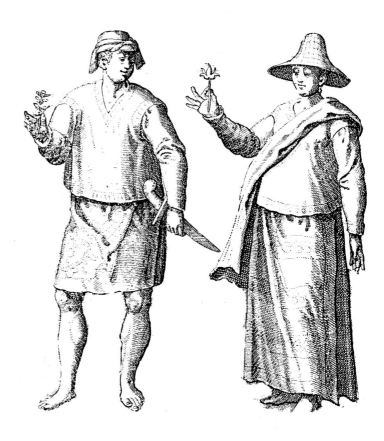

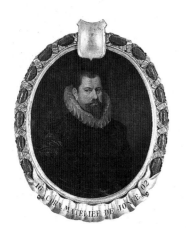

Portugal and got him a position with the new Archbishop of Goa, who was about to leave for his new post. This was how Jan Huygen van Linschoten, as a boy of not yet twenty, made his voyage to the East. It was to be a fascinating experience for the sailor from Enkhuizen. He kept a journal, made sketches and notes. He noted information about places he did not see for himself from the tales of others. The Antwerper Gerrit van Afhuyzen told him about Malacca, the city which was a trade entrepôt 'of all India, China, the Moluccan islands and other nearby islands'. In spite of that, said van Afhuyzen, few Portuguese resided there 'because the land was unhealthy and the air heavy, for both natives and foreigners'. Van Linschoten also copied information about the language, called 'Malayo', which was held to be the most courteous in the world. Men and women both were notably 'amorous' and loved 'refrains *(pantun)*, songs and other amorous rhymes'.

After a sojourn of six years in Goa, Jan Huyghen returned to Spain and then to Enkhuizen, where he arrived in September

1592. He worked out his notes, added matters of interest contributed by another burgher of Enkhuizen, doctor Paludanus, and, apparently under influence of the reformation, which in the meantime had reached the small harbour town, wrote a moral chapter concluding his *Itinerario*. In 1595 this book was published by the famous Amsterdam printer and bookseller Cornelis Claeszoon.

First Voyages to the Indies

A strong desire to make the voyage to the spice islands independently from the Spanish enemy had led to the establishment of a *Compagnie van Verre* ('Far Company'), which equipped the first Dutch fleet to voyage to the Indies in the year Jan Huyghen's book was published. It consisted of three merchantmen and a schooner, commanded by Cornelis de Houtman and Pieter Dirkzoon Keyzer. Jan Huyghen van Linschoten's brand-new

Below: Frontispiece illustration of the published history of Matelieff's voyage to Malacca, 1608.

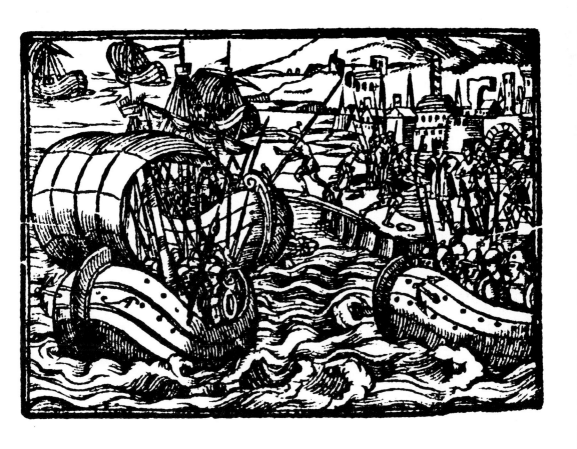

Below and below right: Detailed drawings of a sea battle between Matelieff's ships and the Portuguese off the coast of Malacca in 1606. The Dutch ships carry a striped banner (red, white and blue), the Portuguese a flag with a (red) cross.

itinerary had been taken along. However, commercially and politically the voyage was a failure. Loss of life was great, just eighty-seven of the original 240 crew members survived. The spices brought along were barely sufficient to cover expenses. Houtman's undiplomatic manner had not been suited to winning the confidence of the native rulers. But the voyage did contribute greatly to the self-confidence of Dutch merchants: they had made it to the Indies on their own. In the ports of the Dutch provinces of Holland and Zeeland, companies were formed and ships were equipped. Voyages were made to China and Japan, contacts were laid on the Moluccan islands and the Rotterdam inn-keeper Olivier van Noort was the first man to sail around the globe. For the time being Portuguese strongholds such as Goa and Malacca were avoided and trade was done in places such as Bantam,

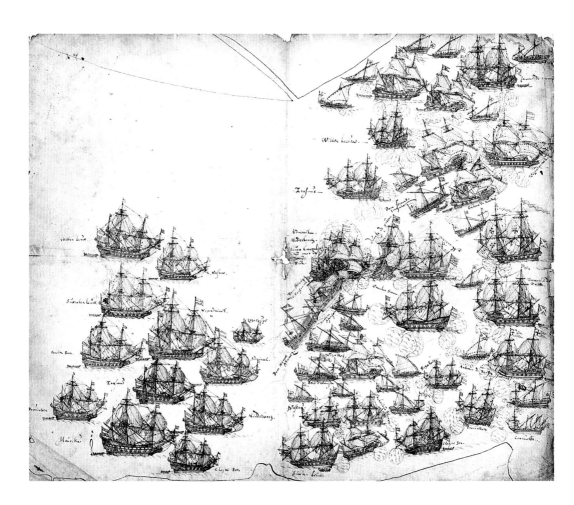

where the sultan conducted an open trade policy. But the Dutch aimed at acquiring a permanent base and a greater portion of the spice trade, preferably the monopoly. Malacca would make a perfect base, but an army was needed to take it from the Portuguese. Jacob van Heemskerck, in the service of the Amsterdam Company, found an ally in Sultan Ala'udin of Johore, a descendant of the Sultans of Malacca who had been attempting to retake what had been taken from them by the Portuguese. The sultan sent an envoy along to Amsterdam to convey his goodwill to the company administrators. Regrettably the man died on the way. However, his retinue of Malays reached Amsterdam, and one of them, a certain Intjeh Kamar learned enough Dutch to be able to act as interpreter for negotiations between the Amsterdam company and Johore.

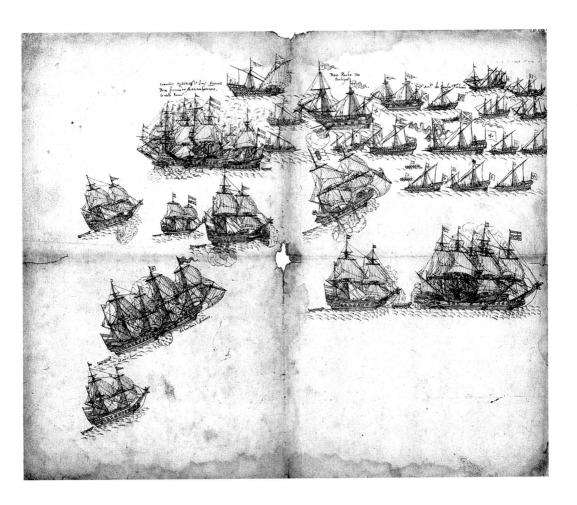

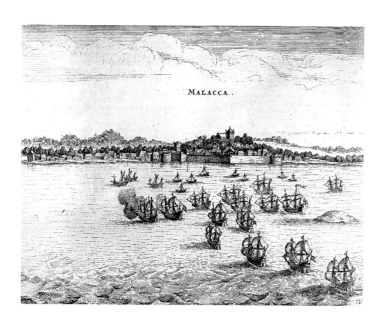

MALACCA.

Above: A battle between the Dutch and the Portuguese in 1606.

At around this time an end had come to the proliferation of companies. At the urging of men such as the politically powerful Johan van Oldenbarneveldt, and in emulation of the British, the *Vereenigne Oostindische Compagnie* (VOC), the Dutch United East India Company, was established in 1602. Its goal was now to acquire an administrative and trade centre in Asia, and this was to be either Malacca on the Malay peninsula, or Jacatra in Java. Bantam was less suitable because its powerful ruler saw no need to give a foreign power a privileged position in his territory, and the influence of the Chinese merchants turned out to be insurmountable. In 1603 Jacob Pieterszoon van Enkhuizen travelled to the peninsula with a small fleet, and paid a visit to the sultan of Johore. Pieterszoon's ships had helped Johore to repulse an attack by the Portuguese, to the great satisfaction of the sultan. Cornelis Matelieff de Jonge, admiral of the third Dutch East India Company fleet of 1605, also visited the sultan. Matelieff was not wholly taken in by the life at the court. The lifestyle of the nobles and princes in Johore apparently irritated him: 'By his third wife the old King of Johore has a son, named Raja Laut, or King of the Sea, a man whose only talent lies in smoking tobacco and drinking *arak* and then eating betel; he is worthy to be sunk in the sea bound hand and foot; a great drunkard, murderer and whoremonger, who has memorized all that matters regarding these three items.'

It became increasingly clear to the sultan that Dutch friendliness and help did not emanate as much from a desire to help return the lost territories as to nestle in Malacca themselves. Nevertheless, a treaty was signed between the sultan and Matelieff, which mainly stipulated a joint conquest of Malacca and the establishment of a trading post in Johore. In May 1606 Matelieff's men landed on the coast of Malacca. However, Matelieff commanded sailors, not soldiers, who were not organized militarily and unable to take Malacca. Also, the cautious Sultan of Johore had sent no help. When Portuguese ships arrived, Matelieff was able to beat them off, but it still proved necessary to withdraw to Johore to recuperate. Some men under the merchant Abraham van den Broek were left to continue work on the trading post. Matelieff staged one more unsuccessful raid on Malacca, and then voyaged on to the spice islands.

Above: Pieter Willemszoon Verhoeff.
Below: Verhoeff's men landing at Malacca.

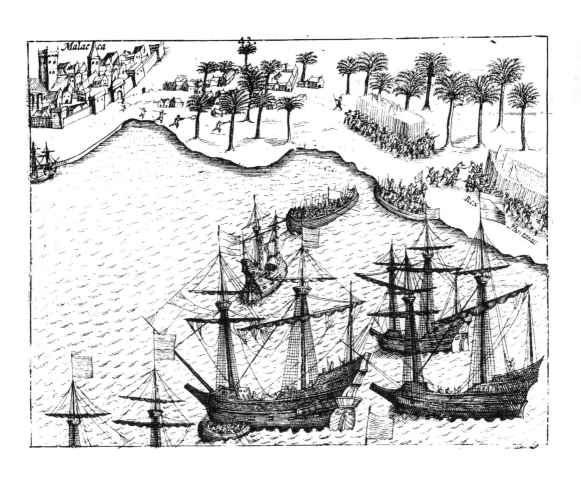

Verhoeff's Attack

A year later it was the turn of admiral Pieter Willemszoon Verhoeff, commanding 13 ships. The fleet left the northern Dutch island of Texel in December 1607. On board the *Hoorn*, a ship from the town of that name, was the later Governor-General Jan Pieterszoon Coen making his first voyage to the Orient. It would not be an easy voyage. After many problems the ships reached the Straits of Malacca in November 1608. Verhoeff's secret orders included an attempt to capture Malacca.

At some distance from the port, a large Portuguese ship lay

Below: A selection of spices as carried from South-east Asia to Europe by the VOC.

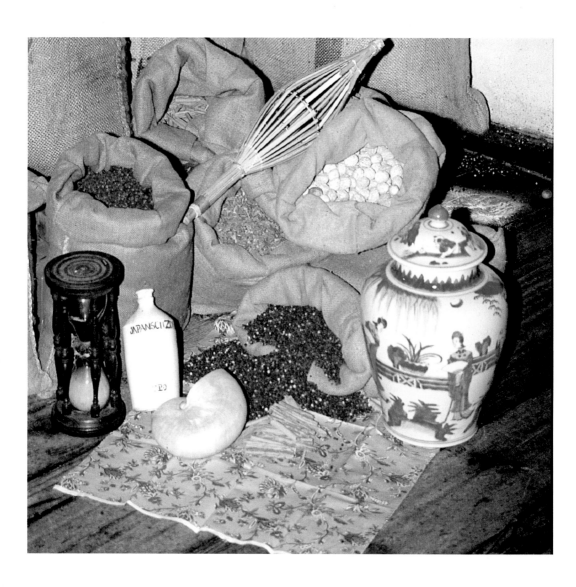

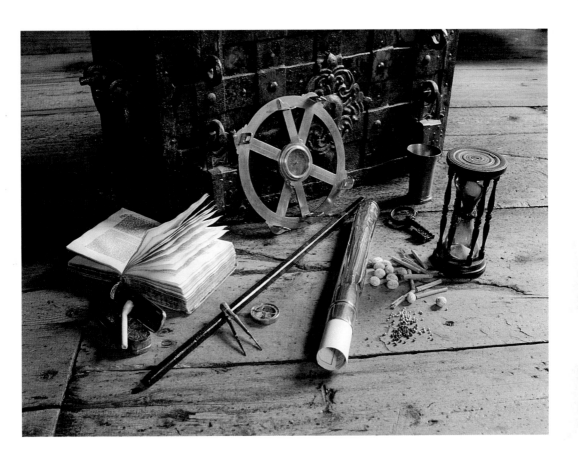

anchored. Verhoeff attacked it at once, but the crew quickly made their escape. The booty was disappointing: just rice and coconuts. But the attack had raised the alarm in Malacca, and sixty ships fled in all directions. The Dutch fleet coursed back and forth and finally a number of soldiers and sailors were put ashore on the nearby islet, present-day Pulau Pinang, where carpenters started putting together prefabricated sloops. Verhoeff planned to send two sloops to Batu Sawar, residence of the Sultan of Johore, and the place where Matelieff had left the merchant Abraham van den Broek. Van den Broek was to be directed to ask the sultan for assistance in securing Malacca. While the sloops were underway, the rest of the fleet sailed up and down the straits looking for booty. On December 1, a ship hove into sight captained by a Frenchman who, six years before, had been captured by the Portuguese while serving on a Dutch ship. He gave useful information about the defences of the city; he also said that everything

Above: A VOC chest, navigation instruments and other attributes.

was in an uproar. In the meantime the Portuguese had carried out a successful night attack on Pinau Pinang, overwhelming the unvigilant sentries. There had been casualties and three VOC soldiers had been captured, prompting Verhoeff to reinforce the island's garrison.

December 2, was the day a soldier who had been awaiting punishment was keelhauled. On the 3rd a Javanese junk loaded with rice was intercepted. The crew hastily said they were friendly with Johore and also liked the VOC. The rice was subsequently bought at a reasonable price and the Javanese were allowed to go on their way. Very different was the fate of Portuguese merchants who innocently sailed into the Straits of Malacca: the Dutch ships would attack at once and try to take the Portuguese ships. The Portuguese defended themselves fiercely, causing one of Verhoeff's ships, the *Zeelandia*, to withdraw for repairs. One large ship with a complement of 110, including forty Portuguese and many Chinese, was taken. The valuable cargo consisted of velvet, silk, damask, medicine, pepper and porcelain. There were also three monks aboard who were deemed eminently suitable as exchange against the three captured Dutch soldiers. One of the Chinese was sent to Malacca with a letter and after some negotiation an exchange took place some distance outside the city.

The Sultan of Johore

On December 11, some dugouts approached with news that the merchant Van den Broek had run into trouble. He wished to bring out report personally, but his boat had become involved in a chase after which he had gone ashore near Malacca. He was now waiting to be rescued. Van den Broek reported that the sultan did not wish to explicitly take the side of the Dutch. This was not unreasonable: compared to the Portuguese presence, Dutch power was not very impressive.

Verhoeff then decided it would not be possible to take Malacca: the city was 'well supplied for years with ammunition and victuals, her walls and fortifications were so disposed having many large cannon, including two extraordinarily large pieces, which could shoot far, that attackers would be grievously damaged'.

It seemed more prudent to pay respects to the sultan of Johore. On December 29, to the great relief of the Malaccan populace, the ships weighed anchor and left for the Straits of Singapore. Upon

arrival, Verhoeff and members of the ships' council embarked in
smaller ships. They sailed past 'two small hills or islands like
sugar loaves' up the Johore river and were ceremonially received
in Batu Sawar. Elephants carried Verhoeff and his men to the sul-
tan's court. The next day the *ramadan*, the month of fasting, was
concluded with the usual pomp and circumstance, greatly
impressing Verhoeff and his men. In the afternoon there was a
banquet: in honour of the guest the table was arranged European-
style with chairs and cutlery. Exotic female beauties were not
lacking: 'Halfway through the meal two girls did a comical dance
to the sound of drums and singing women danced, it was strange
and amusing to see'.

Boat trips and other meals followed, but the sultan craftily
appeared not to hear the request for permission to establish a
Dutch fort. He did, however, appreciate the money, cannon and
ammunition to fight the Portuguese. More meals followed and the
Dutch organized a mock battle, to the great amusement of the
Malays. Verhoeff received a gold kris from the *bendahara* and
gave his own sword in exchange. The sojourn was not as pleasant
for everyone. A sailor who had been guarding the boats was sur-
prised by a crocodile while swimming in the river. Only 'a frag-
ment of his innards' was recovered. Finally the sultan received a
complete Dutch costume and 3000 reals, twenty barrels of gun-
powder and material to cast bullets. Some of the Dutch were left
behind at the trading post. The fleet continued its voyage, during
which a sailor who had been cooling off in the sea was attacked
by a shark which 'bit off a large piece of flesh from his side'. He
died in terrible pain. His mates hunted the shark until they caught
it, cut it open and buried the flesh bitten off with the rest of the
sailor's remains.

The Alternative of Batavia

After the repeated failures to take Malacca the attentions of the
voc switched to Jacatra on Java. Jan Pieterszoon Coen had a mete-
oric career and convinced the voc's directors of the importance of
a better base in Bantam. In 1618 Coen was appointed governor-
general at Jacatra. Immediately he set to work to expand the
Dutch trading post to a powerful fortress. A conflict with the local
ruler was inevitable. After hazardous exploits, the subjugation of
Jacatra was finally complete. Coen energetically worked at the

reconstruction and expansion of the city and the fort, a work continued by his successor. The city was named Batavia, although Coen himself preferred Nieuw Hoorn ('New Hoorn').

The VOC finally had its base in Asia. In addition, it had proved it unnecessary to sail by way of Malacca. In 1611 Hendrik Brouwer had discovered that it was much more advantageous to sail a course due east from the Cape of Good Hope through the Indian Ocean, using the trade winds to veer north and to reach the Indies through the Sunda Strait between Java and Sumatra. Nevertheless, Malacca remained an important trade entrepôt, and plans were repeatedly made to conquer it.

The Siege of Malacca

In August 1640, the Dutch East India Company in Batavia amassed the largest possible force of ships, sailors and soldiers off of Malacca. Johore helped by stopping shipments of rice bound for Malacca; these mainly came from Mataram in Java, a sworn enemy of the VOC. Relations with Aceh were such that the Portuguese need not expect help from there. Still, hopes for taking the city quickly, weakened as it was by previous attacks, were soon dashed. The city was so well-defended by cannon that the VOC soldiers were unable to approach. In addition, the Dutch were unable to institute a complete blockade, and the defenders of Malacca slipped through at night in small boats and brought in food and ammunition. On the land, full encirclement also proved impossible. The Dutch settled down for a wearying siege that would last for months. Their soldiers dug in, out of cannon range, putting up earthworks and dragging in artillery. Artillery bombardments alternated with assaults were used to attempt to breach the defences, but these proved too strong and the assaults cost so many lives that they were discontinued. Then VOC defectors betrayed the positions of the besiegers; the Portuguese changed the positions of their cannon accordingly and managed to inflict serious damage to earthworks in the besieging cordon. The Dutch decided to starve out the city, because as their leaders saw it 'Malacca was not a cat to grasp without a glove'. A stream of letters requesting reinforcements and more ammunition was sent to Batavia. Partly by means of 'small inducements' or else by grim talk, the rulers of Johore were stimulated to intensify their blockade efforts. Dutch patrols ventured into the interior and destroyed

kampongs and ricefields to prevent Malacca from being supplied from there. In the meantime the rainy season had begun. The heavy damp heat, the downpours and eating fresh fruit caused dysentery and dropsy. 'Disease reigns over our men; there are two hundred in hospital, over three hundred are down', the leaders wrote Batavia. The Dutch soldiers lay in camp seriously ill, sailors died in their bunks. In the captured Church of St Thomas, the first Dutch were buried. Morale dropped, and even the Reverend Johannes Schotanus took to drink instead of giving support to the troops. So many higher ranks fell victim to disease that the besiegers were about to become leaderless.

Batavia did its best to maintain the siege, but also had the unstable situation in Java and the Moluccas on its hands. However, conditions in Malacca had become increasingly difficult. From deserters and intercepted letters it was learned that the Malay population had largely fled the city. The remnant was starving, reduced to eating dogs and cats. Chickens had almost entirely disappeared. At night attempts were made to forage in the forests around the city. 'All the blacks are so thin and poorly that they cannot be regarded without pity', the Dutch East India Company commander reported. The Dutch won an important victory when they captured the monastery on *Bukit Cina*. From there they started to bombard the nearby city. Assuming that Portuguese resistance was coming to an end, the Dutch sent two 'papists' with a white flag to negotiate surrender. The peacemakers received a warm welcome: their flag and clothes were burnt and a red flag was planted in the earth. 'With their tails between their legs' and trembling with fear the clergymen returned to the Dutch camp. Unfortunately for the Portuguese, anxiously awaited reinforcements from Goa never arrived. From Batavia there arrived Minne Willemszoon Caertekoe, who would command the last assault on the exhausted city.

The Fall of Malacca

The assault started in the night of Sunday, 13 January to Monday January 14. Everyone, well or ill, was ordered to take part. Approximately 650 attackers were divided into three groups and equipped with grenades, spears, cutlasses and ladders. Before daybreak the bridge over the river was provisionally repaired so that the troops could get closer to the city. The Portuguese

Victims

Nicolaas de Graaf from Alkmaar was ship's doctor on the *Nassau*, a ship of the Hoorn chamber, and was preset at the conquest of Malacca. In his journal he wrote: *'During the siege we lost a thousand men, white and black; there were many severely wounded: in various cases arms and legs were amputated, some had a hole drilled in their skulls, and other operations were done, too many to recount'.* After the siege was over a wounded Dutch soldier was found: *'This wounded man, upon seeing our soldiers, asked them to shoot him as he believed he could not be cured; the soldiers refused and brought him to our tent in a hammock, where he fortunately recovered with only a stiff arm to show for his wounds. This patient had two bullet wounds in his chest. One bullet had entered at the chest bone and had exited in his right side; the other had entered under the collar bone and had exited above his shoulder blade. He also had a bullet wound in his right arm, two cuts in his head and his right leg had been mangled, which is why he stayed down and did not come forth with the other fleeing soldiers.'*

resisted fiercely but when Dutch troops had reached a large breach in the wall, the capture of the city was just a matter of time. At ten in the morning, Malacca was in hands of the Dutch. After a drum signal, the soldiers were allowed to plunder all they liked. The booty surpassed, despite the exodus since the beginning of the siege, their greatest expectations. The goods and valuables commandeered by the VOC from merchants' houses, palaces, churches and monasteries were more than enough to cover the expenses of the siege. The surviving Portuguese and their families were allowed to leave for Negapatam, for which the Dutch supplied ships and passes.

Manuel da Sousa Coutin, governor of Malacca, presented Caertekoe with a gold chain in appreciation of his courage and mildness. The Wednesday after the victory was declared a day of thanksgiving and fasting. The ship *Kleine Zon* ('Little Sun') was forthwith sent to Batavia with the glad tidings. 'With joy I am able to inform your lordships that God Almighty on January 14 anno 1641 has given the city of Malacca into our hands', the letter rejoiced. It went on to say that the final investiture had only cost 30 dead and 60 wounded. The courage of the attackers was praised, particularly that of a lieutenant Jan de Moff.

Restoration of the Fortress

The Dutch worked feverishly to defend the city against possible recapture. Slaves of the Portuguese were used to bring in building materials and to repair walls and fortifications. From Johore, two hundred labourers came to pull down earthworks outside the city and to demolish useless or badly damaged houses. The fathers at the various monasteries proposed to continue their work under supervision of the Dutch East India Company. But the Dutch were in no mood to comply and wished to see the last of these 'fitful people, whose grubbing machinations are known all over the world'. The nobles and commanders of Johore were thanked with small cannon and some trinkets. But an attempt by the Dutch East India Company to restore relations between Aceh and Johore failed, so that, from the start, Malacca under the Dutch East India Company was flanked by allies at odds with each other. At the end of January, the ship *Heemstede* set out to inform the motherland of the victory. Reactions in Europe were mixed. The joy of Dutch East India Company administrators and shareholders was

boundless. England and France were highly envious. It was rumoured that Malacca had fallen through the treachery of the Portuguese governor, who had supposedly succumbed to bribery. The Dutch dealt with this account as a fabrication; they praised the valour of the Portuguese defenders. The bitter reaction in Portugal was that the loss of Malacca entailed the loss of the Indies.

Iancoma · Pegu

PEGU REGN

Ancomorin · Dagon · Macaon · Tangu · Qua
Daobaca · Casmi · Toqualla · Manar

PENINSULA · Omequera · Iuropisan · Laniang

Alagada · Marmelo · SIAM · Martaban

I. de Maon · Macarea · Louvo
los Reyes · Bancosey
Siam · Odia · REGN
moro · Banco
makelang · Anio
Liam · Lieuve

I. de Andemaon · Merguib · Pipili · CAMBO
Citre Andemaon · I. Demdiq · Chantaom · Ponom
Tand · Sinus · Langor
I. Possa · cerim · Iaxvata · REG
Razo · I. Carnicular · Burdid · Carol
Ionca · P. Cornon
Sombrero · Ligor · Siami
de Palmar · Iuncalaon
Calaoive
I. Nicubar · Iungar · P. Cara
I. Nicular · Bor · P. Coxyn
delon · INDIÆ
P. Way · Achem · ubi
Pedir · Queda · Patane · P. Rindang
Daya · Pacem · Chanton
Papon · Gora · Iordlo · Bateset
Lafan · Liabon · Barvaz · Dago · P. Capas
Deli · Perah · Calantam · Ariabo
Cocos I. · Gouson · parsalar · Pam
Logebi · Pahang
Ouro · Corah · Malacca · P. Timaon
Gosang · Anamba
Baras · Iho
P. Nayas · P. Romania
Iansel
Kinkom
Linga · I. Bintam
Iricon · Bantam
Soucon · Andregery · I. Linga
sinca · I. Almeirains
Indapora · Iamby
Ravatupo · Batacarang
Iamanite
Palambam
sillacar
Pasangun
Poniong · Gondon
Lampin

De Vaste Kusten
en Eylanden van
INDIEN
van
EGU en MALACCA
af, tot aan de
MOLUCCOS, etc.

Banten · Baty

Milliaria Germanica Communia 15 in uno Gradu
50 · 100 · 150

The Dutch East
Indies Company (VOC)
in Malacca

Restoring Order

The Dutch did their best to rebuild the defences of Malacca and
to restart trade as quickly as possible. It was not an easy task.
Soldiers were needed to control the 'inhabitants of surrounding
villages, who were beginning to prick their ears'. Also, the siege
had seriously damaged the city. Commissioner Justus Schouten,
arrived from Batavia, described the situation as follows in his
report to Governor-General Anthony van Diemen: 'mighty walls,
impressive buildings, good land, beautiful gardens, but plundered
bare, fever-ridden and impoverished'. The heavily damaged
tower, the pride and joy of the Portuguese, was partially pulled
down. Churches and monasteries became arsenals or hospitals or
were also demolished. The forts were renamed after family mem-
bers of the Stadtholder Frederik Hendrik: Henriette Loyze, Aemilia
and Ernst Casimir. A strategically located battery was named 'Look
in the Pot' and Fort St Domingo, by which the victorious Dutch
had entered the city, became Fort Victoria.

To set an example, two soldiers who had defected during the
siege were hanged amid great public spectacle. Ensign Evert Jansz
was punished posthumously for cowardice. His corpse was disin-
terred as being 'unworthy of the earth' and heaved onto a rack,
coffin and all. His head was put on a stake. On the other hand,
the remains of the officers Adriaen Anthoniszoon and Jacob
Cooper were reinterred with great ceremony. Their remains,
which had been buried in the church of St Thomas, were brought
into the city in a flag-covered sloop. On July 17, after the bells of
the St Paul's church had sounded the death knell, a solemn pro-
cession went up the hill. In front there were 150 musketeers with

Left: Detail of a 17th-century
Dutch map of the Malay archipel-
ago. On the peninsula several
current placenames can be recog-
nized: *Queda* (Kedah), *Perah*
(Perak), *Ihor* (Johore), Pahang,
Calantam (Ketantan), *Patane*
(Patani), *Nauw van Cincapura*
(Straits of Singapore, now called
the Straits of Malacca). The entire
peninsula used to be called
Malacca by the Dutch. The town
proper is, of course, also indicat-
ed.

muskets inverted and standards dragging. The officers wore black sashes and the drums were covered in black damask. These were followed by men exhibiting the honours of the deceased and then came the coffins, with the carefully selected bearers. Chivalry still played an important role: the Portuguese community was amply represented at the mourning service to pay their respects and commiserate. After a sermon by the newly arrived Minister Loosveld, the firing of salutes and the beats of the muted drums, a wine-drenched banquet took place, and Portuguese authorities were also 'given a stately treat'.

There were also happier occasions. In the ruins of Malacca youthful love had blossomed and to prevent the extramarital relations so abhorred by calvinist ministers, a number of hasty marriages between VOC men and Portuguese widows were consecrated. As the text for his sermon the Reverend Loosveld chose 1 Thessalonians 5:17 'Pray without ceasing'. Slowly life returned to normal. The fever epidemic abated. 'The clearance and purification of the city, as well as refreshing showers have changed the

Below: Malacca in the 17th-century. Among the ships are several large Dutch ships and sloops, but also smaller local boats and Chinese junks.

unhealthy and stinking air for the better'. The reconstruction was taken in hand with doubled energy.

Rules

The many irregularities in Malacca irritated Commissioner Schouten and to 'repel disorder' and 'bring about good policing', he had a number of placards made 'against the monopolistic trade of foreigners, the departure of freemen, the keeping of taverns and hostels, dice and gambling, night life and concubines, absence from sentinel posts, harming fruit trees; the sale of merchandise, furniture and ammunition; breaking open coffins and other robbery of the dead, not paying bills, slipshod accounting and making wills, classification and valuation of gold and silver coin, the export of Spanish reals, regulations for the Bazaar, the declaration of incoming and outgoing goods, concealing the same, the usual tax, unitary measure and weight, and all food priced moderately, besides other good regulations which are praiseworthy'. Schouten did not approve of marriages between Dutchmen and Portuguese mestizas 'because these women are habitually lazy, sensual and extravagant; although clever, disproportionately luxury-loving, as most will show with their shameful lives'. Justus Schouten made himself unpopular because of his unrelenting attempts to trace illegal plunder. It was an open secret that during the capture of Malacca, many Dutch, including Caertekoe, had laid their hands on more booty than they were allowed. For days, churches, monasteries and merchants' houses had been turned inside out for valuables. But the plunder had only partly been recovered by the voc. Schouten had no qualms about having Caertekoe's sea chest searched, and that yielded 'a gold-worked box, as well as two large bags of money'. The accountant was accused of shiftiness because he had not kept an accurate tally of the plunder. A senior merchant, two captains and a master were forced to return 20,979 guilders' worth of their booty. This had 'vexed the gentlemen in question, and they have protested, even to me, in cross and arrogant terms, so that I am detested by all', Schouten complained. But the post of commissioner is a 'hateful service', he added. A placard appeared, announcing that everyone who gave the location of a hidden treasure would be able to retain one-fifth of its value. That had good results. A Portuguese boy betrayed the hiding place two monks used for jewels and

The Climate of Malacca

In his report to the Council of the Indies, Justus Schouten wrote about the climate and how to deal with it: *'Use especially the morning to wash the body clean; use the cool mornings or evenings to take walks or other exercise; prudently avoid the hot sun, fiery drink and making love; maintain a healthy diet of food and drink; these are the very best means to live healthily in Malacca and elsewhere'* (written on the schooner *Franeker* voyaging from Malacca to Batavia on September 7, 1641).

other valuables.

While the officers and administrators may have been able to hide their share of the booty with the intention to smuggle it back to Holland later, the uncouth soldiers and sailors sold their valuables 'artlessly to crafty Moors', Schouten reported mournfully. Silver, cloth, and expensive furniture were traded for chickens, fruit and fish, for twenty times less their worth. Sometimes a silver dish was paid for with a bunch of bananas.

Profits and losses

The administration of Malacca was organized along the usual colonial lines, with Batavia as the nerve centre, although some factories in Sumatra and Malaya were supervised directly from Malacca. The governor was assisted by a council, which included the treasurer, the senior merchant, a secretary and representatives of the military, the fleet and the church. Portuguese administrative posts such as Captain of the Portuguese and Captain of the Chinese were retained, as well as the Malay post of *shah bandar*, a sort of harbour master, although it was a VOC employee who filled the position. Taxes were regulated in detail. The cargoes of all foreign ships were subject to duties, ten per cent of incoming and five per cent of outgoing cargoes. Ships with more than four people aboard paid a head tax. There was also an anchorage tax and the VOC readily adopted the custom of *ruba-ruba*, a kind of polite gift, although Justus Schouten objected to this usage as facilitating corruption.

Ships hoping to avoid these taxes were intercepted and forced to stop at the port to fulfil their obligations. This was so ordinary for the VOC that those who resisted were called 'bloody self-serving Malays' by Schouten. The exchange rate, based on the Dutch currency, was carefully calculated. For weights and measures the Malay system was retained with the exception of the wine measure for which the Dutch *flapkan* was introduced. As in Batavia, the administrators' goal was the closest possible approximation to a Dutch town.

The Clergy

Unlike the Portuguese, the Dutch felt no need to convert the local populace. But of course the spiritual needs of the Dutch had to be attended to. Clergymen were asked by the various chambers of

the VOC to sign a five-year contract, 'not including the voyage out and back'. Married ministers were expected to stay ten years, in view of the higher expenses the VOC was incurring in their case. Of course, efforts were made to renew the contracts, as it took time to acclimatize and to learn the language and customs. Through bonuses, free housing and other advantages — for example a certain Reverend Schotanus received a thousand guilders as his share of the booty after the siege of Malacca — an attempt was made to make life in the Orient more attractive. But in general there was not much enthusiasm, which is not surprising as it was not the cream of the nation that the clergy in the Indies had to contend with. The 17th century Reverend Vertrecht typified them as 'mostly ignorant and godless, rabble from Sodom and Gomorrah, incurable, and through whoremongering, drunkenness and despising God's word they show they have neither God nor religion'. Shortly after the end of the Dutch East India Company, a certain J. Haafner reminisced during his voyage to Ceylon with the words: 'The East Indies became the workhouse of Europe, the ne'er do wells, the extravagant, debtors, criminals, all those

Below: The VOC ship *Pieter en Paul.*

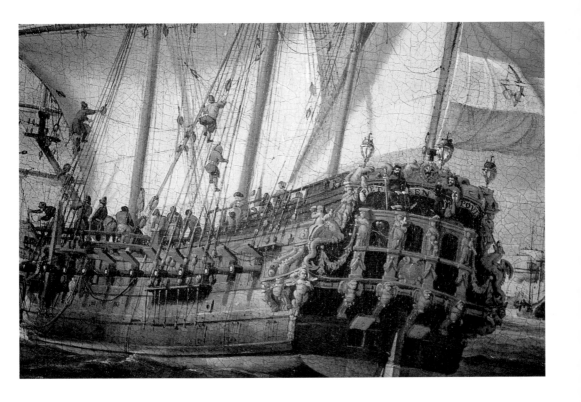

banished for their crimes, the bankrupt, all made for the Indies as to their common prey. Everyone wished to make a fortune, they came to steal from the Company, the subjugate, plunder and murder the inhabitants. Of the ten who returned rich, nine made their money this way.' In Malacca, the Dutch community consisted of between three and five hundred soldiers, company employees and a handful of independent citizens. Every Sunday two services were held, in the morning in St Paul's church on the hill, and in the afternoon in the church below. Often enough two ministers were stationed in Malacca at the same time, which sometimes gave rise to difficulties, as in 1657 when the Reverends Breil and Bonnus became involved in a physical confrontation which resulted in one being transferred to Batavia. Often the ministers scathingly criticized company employees who kept slaves, traded in opium or other dubious products, and committed excesses with drink or women. When the reverends became an embarrassment to the local administration, a transfer was arranged. Also, to the regret of ministers and church councils, the Dutch East India Company exercised its right to send a 'political commissar' to church council meetings. The clergy were assisted by consolers of the sick, mostly simple artisans who could show they could read the Bible and sing their psalms and were sent out to visit the sick, the dying and stood by the condemned during their last moments of life. They organized things such as letters home and personal affairs. In that way a good consoler of the sick could become a trusted figure. In Malacca as elsewhere there were consolers of the sick who knew Portuguese and Malay and worked with the native population. The administrators even had the catechism translated into Portuguese. After some initial clashes, the descendants of the Portuguese and Roman Catholic Malays were allowed to practice their own religion. The voc did not share the zeal of the Jesuits.

Description of Malacca
In his report to Governor-General Anthony van Diemen, Commissioner Justus Schouten gave the by far most accurate description of the buildings in Malacca as they were at the time the Dutch arrived. Schouten made minute inspections of the houses, churches and monasteries. He had Reverend Loosveld count the books of the Jesuits, which amounted to 460 theological and

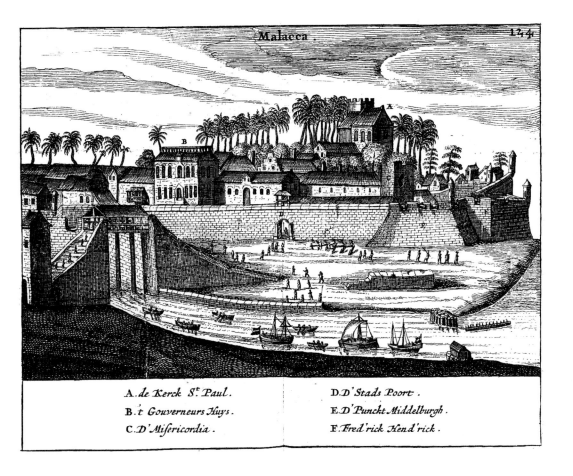

A. de Kerck St. Paul. D.D' Stads Poort.
B. 't Gouverneurs Huys. E.D' Punckt Middelburgh.
C. D' Misericordia. F. Fred'rick Hend'rick.

85 legal books, all obviously in Latin. The zealous commissioner also had the cannon and church bells counted. Most of the church bells were sent to Batavia to be melted down for cannon. Schouten also described the *Hospital del Rey*, where the Portuguese soldiers had been cared for by an *infermero* assisted by 'eight to ten black servants, a surgeon and two bloodletters'. For the Malays there was a hospital for the poor. From Schouten's description the large number of churches, chapels, monasteries and hermitages in and around Malacca becomes apparent. The cathedral dedicated to the Assumption, which stood at the foot of the hill close to the castle, was the main church, and during the Portuguese period it had a bishop, canons, deacons and a cantor. One beautiful monastery was Madre de Dios on the top of *Bukit Cina*. Although it belonged to the mendicant order of St Francis, it was the most prosperous monastery of Malacca, Schouten says.

Above: Malacca in about 1667. The most important structures are indicated: A St. Paul's church; B the Stadthuys; C *Misercordia*, the jail; D the city gate; E and F parts of the fortifications called 'point Middelburgh' and 'Fredrick Hendrick' (after the Dutch Stadtholder of that time). The illustration comes from Bort's *Voyagie* (see also page 80).

The *Stadthuys*

After the Dutch conquest of Malacca, a house was built for the Dutch governor which is now known as the *Stadthuys* (town-hall). It is the oldest remaining voc building in the Far East.

Right: Photograph of the *Stadthuys*, probably taken at around 1900.

Right below: Proposal for the reconstruction and restoration to the original situation of the *Stadthuys,* prepared by the Dutch architect Laurens Vis in 1979.

Below: The *Stadthuys* today; as with the other Dutch buildings in Malacca's town centre, it is now painted red.

It was this monastery which was captured soon after the beginning of the siege and from where the city was mercilessly bombarded for months.

The small Fort Misercordia (so named because of its slaves' quarters), with its shortened tower, remained in use as arsenal, gaoler's quarters and warehouse. Plans to reduce the large fort to something more manageable came to nothing because of the high expense involved in demolishing the sturdy walls and bastions. A gate dating from the Portuguese period, the only one that still exists, was reconstructed and adorned with the city coat of arms, showing a ship with an armoured warrior on one side holding a crowned sword and a shield with the voc emblem, and on the other side a woman with a palm branch. The principal Dutch East India Company building in Malacca is the *Stadthuys* (Town Hall) which was completed about 1650 and is the oldest extant voc building in Asia. The building is especially interesting as its architecture is based on the (no longer existing) governor's mansion in the former castle of Batavia. The *Stadthuys* was located on the spot where the mansion of the Portuguese governor had been. It

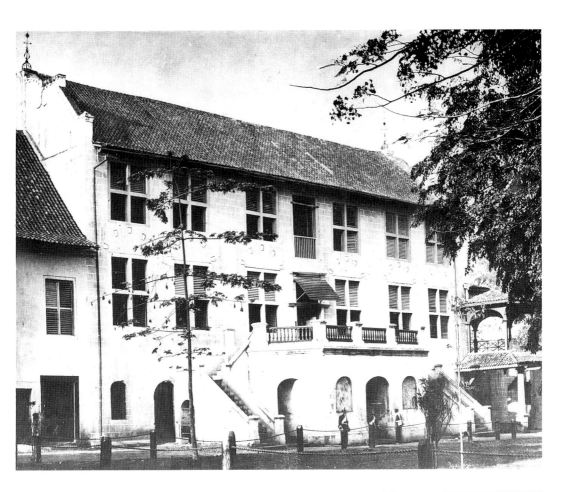

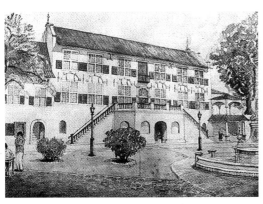

consisted of two floors which included the governor's reception hall and his bedroom. The house had a staircase in front. On both sides this white-plastered building, with its cross window-casing surmounted by decorations in natural stone, was closed in by shops and warehouses. Other VOC buildings included the *Vismarkt* (Fish Market), the *Boomkantoor* (Trees Office) and some private houses. In the middle of the 18th century a protestant church was built at the foot of St Paul's hill, its face clearly influenced by Portuguese architecture. The furnishings, which included a copper baptismal font and a lectern, made a typically Dutch impression. Some 17th and 18th century items of church silver have survived. A silver platter, according to its engraving, was made at the behest of the wife of Governor Bort. A dinner cup, in view of its engraving showing ships chasing each other, apparently commemorates the successful capture of a Portuguese ship.

Besides a few stone buildings, the city consisted mostly of bamboo huts. The large number of palms and other trees gave Malacca a rural appearance. After his visit in 1660, the writer and draughtsman Johan Nieuhoff mentioned the heavy stone walls and bastions, the dense housing and shabby Roman Catholic churches and monasteries. The Dutch appearance of the town was rein-

Below: Elephants were counted among the VOC's merchandise for the inter-Asian trade.
This drawing was made by Jan Brandes in the late 18th century in Ceylon.

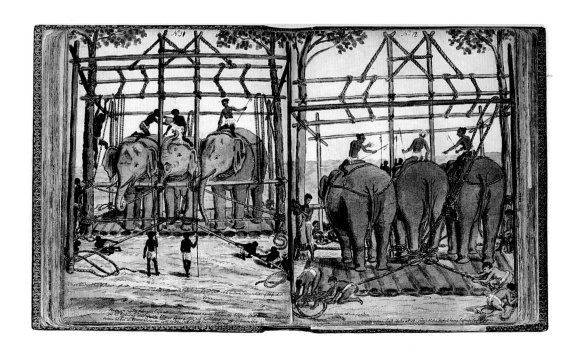

forced by some wide lanes planted with rows of trees and a draw-
bridge across the river. After his visit in 1695, the Neapolitan John
Francis Caveri criticized Dutch intolerance towards the Roman
Catholics and described Malacca as a city inhabited by about five
thousand souls including Portuguese Catholics, Chinese, Malays
and Dutchmen, which meant that the orders of the Dutch East
India Company had to be announced in four languages. Caveri
also mentioned the large numbers of trees which from a distance
made Malacca look more like a forest than a city. Of the earlier
complex on the hill, only the church remained, the other build-
ings had been scrapped. In front of this church the Dutch had
built a lighthouse.

Jan van Riebeeck

Jan van Riebeeck, famous for his founding of the post at the Cape
of Good Hope, continued his career in Malacca from 1662 to 1665
under less fortunate circumstances. He received the rank of com-
modore: in Batavia it was thought that Malacca was no longer
important enough to have a governor. Two years later Van
Riebeeck lost his wife and was left with two children. At his
urgent request, Van Riebeeck was relieved of his post in 1665 and
left for Batavia. Once in Batavia, he was reprimanded for having
too ceremonially, in the view of the Dutch administrators,
received a Portuguese governor whose ship stopped over in
Malacca. However, he was praised for having taken a jesuit off
the ship and for having forcibly dispersed a Catholic meeting out-
side Malacca. Van Riebeeck also repeatedly advised reducing the
large and expensive fortress at Malacca to a smaller pentagonal
fort. Although Van Riebeeck and the governor general in Batavia
sent wood and wax models back and forth, in the end the Dutch
East India Company abandoned the plan because of its high cost.

Versatile Trade

In his report, Justus Schouten summed up the products that were
brought into Malacca: silk, cotton, camphor, elephants' tusks,
slaves, wax, cumin, gold, porcelain, mercury, wicker, cloves, and
much more. The voc traded everything, and that included ele-
phants. It was not easy to transport these precious animals safely;
witness the experience of the *Heemstede*, which sailed from
Kedah in September 1648 with a cargo of not less than eleven

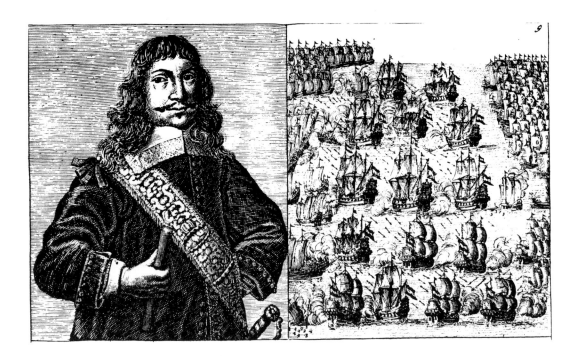

Above: Illustration from *Borts Voyagie naer de Kuste van China en Formosa* (Bort's Voyage to the Coasts of China and Formosa, published in 1674). Balthasar Bort was Governor of Malacca from 1665 to 1667.

On Malacca, the *Voyagie* includes the following: '*This is the strong city, whose hard stone walls are hewn of iron stone, whose high fame will never fail, because she is built solidly and inflexibly, but even more secure this secure fort will be (in the service of the Company) under Bort's wise administration.*'

elephants, and was accompanied by two other ships loaded with banana trees as fodder for the elephants. A storm separated the ships, and the wind brought clouds of locusts and soon the decks and sails were swarming with the insects. After the storm, the ships were calmed; in the heat, drinking water became scarce and some of the elephants died and were thrown overboard. That night the crew of one of the feed ships thought they were running aground, but it turned out that they had bumped into one of the dead elephants.

December was the best month of the year for the Dutch in Malacca; it was when their ships arrived from Japan laden with silver, copper, lacquered wares, camphor and porcelain, and sailed out again laden with tin and spices destined for India and Ceylon. The relationship with the Portuguese was normalized — Portugal had seceded from Spain and so was no longer an enemy — and Portuguese caraques were once again putting in at the port of Malacca. In marked contrast, the Muslim traders from India and the Arab countries were viewed with suspicion. The Sultans of Johore, Perak and Kedah, who had initially welcomed the VOC as an ally against the Portuguese, soon discovered that profit was the paramount concern of the Dutch. The VOC's tested means of making profits were trade monopolies and they stopped

at very little to have the sultans deliver a number of products exclusively to the VOC.

Aceh, the most important supplier of pepper, had been unfriendly towards Malacca and Johore during the first decades of the 17th century and it had often endangered the position of the Portuguese. After his death, the great Iskander Muda was succeeded by a sultan who died after five years. The next four monarchs were women, under whose rule Aceh was less hostile. However, neither polite visits nor threats resulted in any success in the Dutch East India Company's attempts to dominate the Aceh trade.

The Dutch East India Company also did not succeed in extending its trade monopoly to Kedah, a state on the Siamese border. The VOC made a number of attempts to come to an agreement, but the location of Kedah on the Siamese border and its proximity to India made viable controls of the monolopy impossible.

Tin from Perak

Malacca's role in Asian trade, in general, had diminished considerably, and mainly subsisted by levying taxes on traders who sailed in and out of the port. This partly because the spice trade had been gradually moved to Batavia. As an alternative, Malacca threw itself on the trade of tin, which was abundantly available in the peninsula. First by persuasion and later by force, the Sultan of Perak was induced to deliver his tin solely to the VOC. Soon Perak was the VOC's most important supplier of tin. However, despite the continuous presence of ships and a post on the Perak River, the Dutch did not succeed in monopolizing the Perak tin trade. Small boats were able to make their way along the coast with their cargoes, and tin was also being transported overland. After the trading post was raided in 1651, and the Dutch occupants killed, a wooden fort was built in 1670 on Pangkor island, near the shore. Ten years later it was replaced by a stone fort, and the garrison was increased substantially. The English explorer William Dampier visited this fort in 1690 and sardonically described the Dutch fear of the Malays. At about 100 yards from the fort there was a long wooden building where the governor stayed in the daytime. Here Dampier and several other Englishmen were invited to dinner. The guests had barely sat at the table, which was richly decked in silver plates and dishes and

Governor Bort about an Island off Sumatra:

'Bengkalis, a possession of Johore, on an island about a mile off Sumatra, is not more than a fishing village with a sabander *(shah bandar) as its head who represents the interests of the King of Johore. Although it is a fishing village, there are Malay, Javanese and Moorish ships meeting there to trade wares from the Javanese coast, Palembang, Jambi, Indragiri, Achech, Keddah, Pera, Kalang, Johore, Pahang, Patania, Siam, Cambodia, Cochin and China. The Minangkabau, who are inhabitants of Sumatra, appear there in large numbers and purchase much salt and rice as well as fish. At certain times of the year most of the fish is caught by* Selattans (selatan *is Malay for south, presumably Bort meant the* orang laut), *Malay savages who roam among the islands with their women and children. Their fish, and the good roe, is dried and salted and much sought after by the native nations.'*

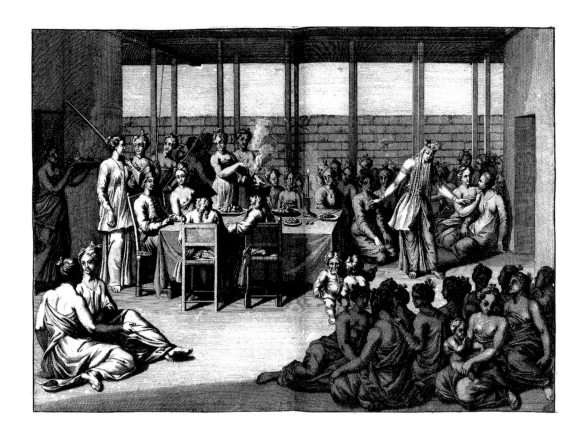

Above: J.F. Gobius, Governor of Malacca from 1726 to 1730, paying a visit to the Sultan of Bantam.

a bowl of liqueur, when the shout 'the Malays' went up. Without thinking of his guests the governor leaped through the window followed by his officers and all the servants. The English then went to the fort, where the ruffled governor was waiting for them. All doors and hatches were locked and the cannon and rifles were wildly fired. It appeared that some Dutchmen out fishing had drifted too close to the coast and had been promptly attacked by Malays. While the rain came pouring down the garrison stood to all night, despite the Englishmen's insistence that the Malays never attacked during heavy rains. The English were perhaps overly critical: the following year the fort was attacked and the entire garrison killed.

Tin as Money

From the times that tin was mined in Malaya, ingots of tin have been used as money, and the various states had their own forms and weights. The last Sultan of Malacca assigned a nominal value which was lower than the market value. The difference gained

him a sort of tax. In Pahang a similar difference was achieved by pouring tin in pyramids which had the required size but were hollow. To show their value, the ingots carried inscriptions. A remarkable custom was pouring the ingots in the forms of figurines such as turtles, crocodiles, elephants or cocks. As there is no discernible weights system in these figurines, it is unlikely that they were used as weights to weigh tin ingots. Perhaps they represented the value of rather heavier tin ingots. In any case, it is known that they were accepted as currency. The different forms were thought to represent talismans.

Below: Plan of Malacca by J.W. Heydt, dated 1744.

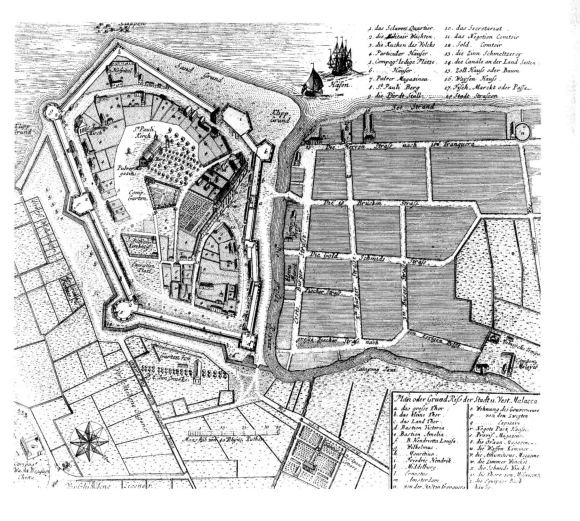

Below: Renderings of Dutch possessions overseas were used to demonstrate to voc directors in Holland what happened with the invested money. This drawing of Malacca was made in about 1660 by the famous Dutch artist Johannes Vingboons.

Divided and Joined

During the long reign of Sultan Abdul Jalil Shah (1623-1677), Johore remained a loyal ally of the voc. The Sultans of Johore, the former rulers of Malacca, were the oldest reigning dynasty in Malaya, and as legend has it, descended from Alexander the Great.

Gradually, however, Johore began to suffer from internal problems. It started with a cancelled engagement to the daughter of

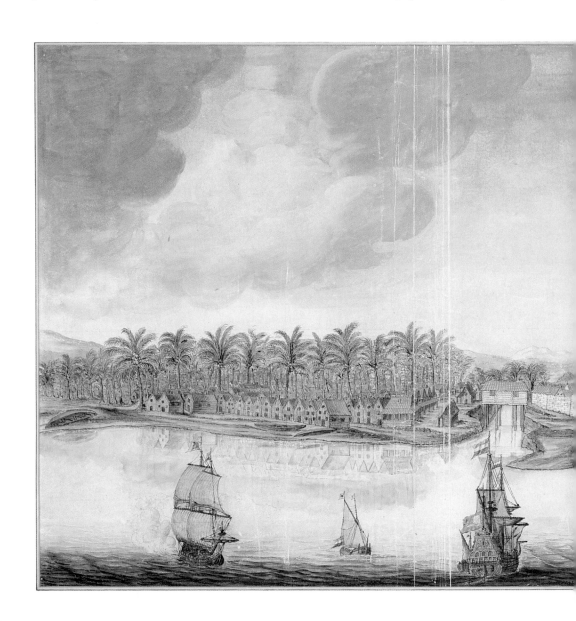

the Sultan of Jambi in Sumatra. Soon after, Abdul Jalil Shah died and was succeeded by his nephew Ibrahim. He hired Bugis warriors from Sulawesi to defeat Jambi. Sultan Ibrahim died in 1685. It was rumoured that he was murdered by three of his wives. His son Mahmud succeeded him. Governor Nicolaas Scholten of Malacca closed a contract with the new sultan whereby the rights of the voc were extended. Also, the voc established a trade monopoly in tin, gold and fabrics along the Siak river in Sumatra,

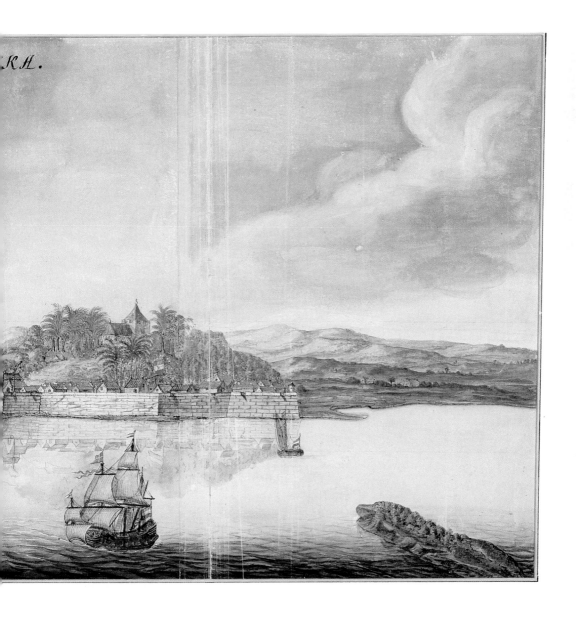

Right: The Christ Church and the Stadthuys. The Christ Church was built to mark the centenary of Dutch rule in Malacca. Its construction was completed in 1753. On the left the first Malacca post office can be seen.

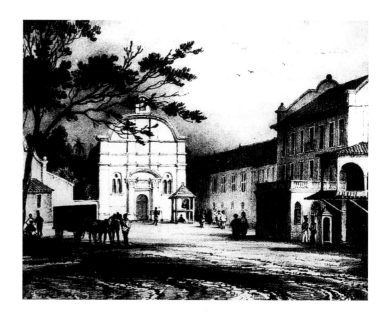

a region that was subject to Johore. Soon it appeared that the treaty's poor Malay translation created many misunderstandings. For that reason a new contract was drawn up in 1689. These suffocating monopoly treaties were not only harmful to Johore and the other Malay states, but in time also to the VOC, because taxes, tolls and protectionist measures destroyed trade in Malacca and aided smuggling and piracy.

Sultan Mahmud appeared not to care; Malay chronicles and Dutch reports describe him as a despot; when he became angry he used the servants for target practice. According to the chronicles he

Below: Dutch plan of Malacca. To the left of the main town the then new area of Tranqueira can be seen. *Bukit Cina* is above right of the town centre.

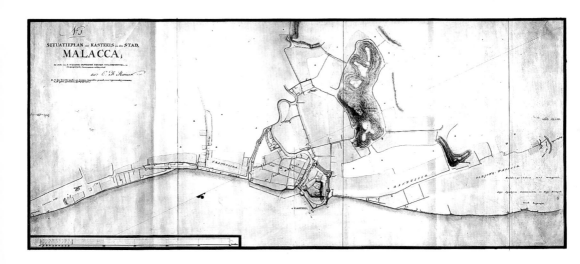

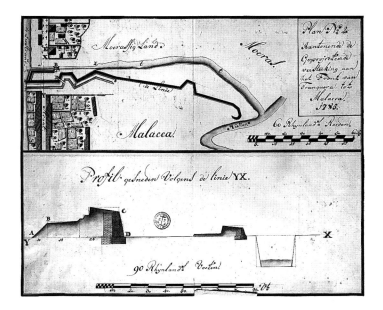

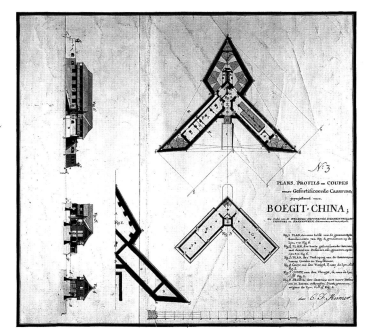

Left: Plan dated 1785 for the fortification of Tranquera.

Below left: Plan for the construction of barracks and armoury on *Bukit Cina*.

was possessed by an evil female spirit which kept him from consorting with women. His revulsion of women went so far that he had a woman in an advanced stage of pregnancy horribly killed: she had taken the stone of a fruit meant for the sultan. The embittered husband, one Megat Sri Rama, swore revenge. He was

supported by a number of nobles, including the *bendahara*, who had had enough. When the sultan, seated on the shoulders of a servant, went to the mosque, he was stabbed to death by Megat Sri Rama. But the sultan had been able to cast a spear into the foot of his murderer. According to a Siak chronicle, grass grew from the wound and Megat Sri Rama died four years later under hellish pains. After the death of Sultan Mahmud in 1699, a shudder went through the whole of Malaya. The murder of a sultan was not only *derhaka*, the worst form of treason and the most terrible act that a man could commit, but in addition a Malay com-

munity uprooted itself by killing its highest leader. This was all the more important as it concerned the oldest Malay dynasty, which ended with Mahmud's death, although the chronicles report that a certain Intji Apune was pregnant by the dead sultan. The child, a boy, was smuggled out of the country immediately after his birth and raised by the *laksamana* of Singapore, which, at that time, belonged to Johore. When he innocently took the seven-year old boy to the court of Johore, the child was at once recognized. People were amazed at the child's likeness to the murdered sultan. The apprehensive *laksamana* brought the child to safety in Jambi, as he was a threat to the successor of the murdered sultan, Sultan Abdul Jalil, the former *bendahara* — not to be confused with the popular sultan with the same name who ruled in the 17th century.

The states of the Malay Peninsula entered a century of insecurity, with power struggles and succession questions, whereby the borders of the present states were largely determined. Kedah was torn by civil war, treaties with the VOC were broken or simply refused, as trade with relatively nearby India was much more profitable. Kedah was also liable for a yearly levy, the *bunga emas* (golden flower), to Siam. Perak, the premier supplier of tin, was also preoccupied with civil war; at one time there was a stalemate in that one side controlled the tin mines and the other

Below: A Bugis kris with a hilt made of ivory and gold ornamentation on its sheath.

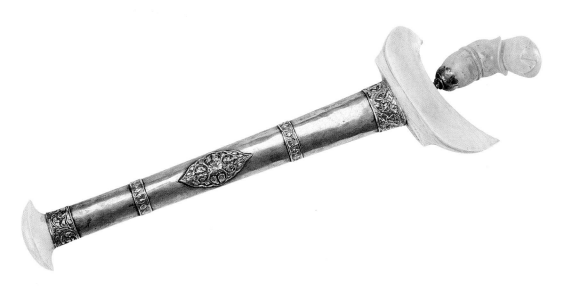

The Name of the Minangkabau

(as told in the *Sejarah Melayu*): *'Once upon a time the inhabitants of Alam on Sumatra were disconcerted by the arrival of an army from Majapahit, the great kingdom on Java. One of the Alam leaders proposed settling the conflict with a buffalo fight. Their opponents agreed. The men of Majapahit sent their biggest and strongest buffalo. But the people of Alam sent a suckling calf. It had not drank for a week and had a poisonous thorn attached to its horns. When the animals were set free in an arena, the calf ran at the big buffalo and started searching for its teats. Its horns pulled open the skin of the buffalo. A little while later the poisoned buffalo fell to the ground. The men of Majapahit returned to their country and henceforth the men of Alam were called* Menang-kerbau *(victorious buffalo).'*

the road to the sea. All this resulted in serious damage to the economy. The VOC lodged many complaints about the cease of the deliveries of tin from this region.

The states along the east coast of the peninsula, Pahang, Terengganu, Kelantan and Patani, had little dealings with the Dutch. Especially the northern two states, Kelantan and Patani, were largely under Siamese control — like kedah, paying tribute with the yearly *bunga emas*. In addition, both states were internally divided. Terengganu, which at that time was a dependency of Johore, had some importance as a supplier of pepper, but strategically was of no considerable significance. Only in 1722, the first Sultan of Terengganu was installed. Pahang was probably the most powerful of the eastern states, and largely independent until the expansion of British interest in the peninsula in the 19th century.

Immigrants

Because the balances of power in Asia were always changing and due to the economic rise or fall of various areas, there was constant migration. In the Malay states there were sizeable communities of Chinese, Indians, Arabs, Minangkabau and Bugis. The Indians were mostly muslims from the Coromandel coast. They were traders, always voyaging back and forth, and had residences in both countries. A chronicle reports an Indian having a wife in both Perak and Coromandel. Many Indians found a place at Malay courts as interpreters or scribes, a caste of civil servants which accumulated influence accordingly.

The Arabs enjoyed high status as they were the people of the Prophet. They were traders, scholars, philosophers and religious teachers.

The Chinese, attracted by the potential of Malay trade, strengthened their colonies that had been there since the times of the sultans of Malacca. The Malay sultans as well as the VOC retained the position of *Kapitan Cina*, head of the Chinese communities. To some extent, the Chinese mixed with the Malays, but, being very traditional in general, they retained their own culture and customs. The Minangkabau, originally from Sumatra, mostly settled in the area later called Negri Sembilan, and kept close ties with the mother country.

The Bugis

One of the most important groups of immigrants in the 18th century were the Bugis from Sulawesi. They were known as traders, shipwrights, experienced seafarers and, above all, as fearless warriors. They gladly offered their services as mercenaries, and Malay sultans would make use of them to decide internal conflict. The capture of the port of Malacca by the Dutch forced many Bugis to find an existence elsewhere in Malaya. Slowly but surely the Bugis were able to seize power in an increasingly large part of Malaya. They claimed privileges because of their help in war, or by intrigue at the courts. The Bugis were realistic enough that they did not strive for the position of sultan, a foreigner as sultan being unthinkable to a Malay, but they did create for themselves the position of *Yang Dipertuan Muda*, a position comparable to that of viceroy normally reserved for the designated successor of a sultan. Other important positions were then taken over, or else the Bugis were able to enter the court through marriage.

In 1717 the supposed son of the murdered Sultan Mahmud appeared in Johore under the name Raja Kecil. Many in Johore believed that Raja Kecil was coming to reinstate the old dynasty; a part of the nobility joined him and particularly the *Orang Laut*, the sea people once forming the sultans' proud navy, chose the side of Raja Kecil. War broke out between the two factions in 1718. After his victory, Raja Kecil married one of the daughters of Sultan Abdul Jalil and settled as ruler in Johore. Abdul Jalil himself fled to Terengganu, where he established a new court.

But Raja Kecil quickly lost the confidence of his subjects. He had some of the leaders of the *Orang Laut* killed and ordered the murder of Abdul Jalil in Terengganu. But his biggest mistake was that he went to war against the Bugis, who controlled much of the west cost of the peninsula. Raja Kecil moved his court to the inaccessible Riau marchipelago, south of Singapore, but nevertheless he was pursued there and deposed. The Bugis took control. Their legendary leader Daen Perani and his brothers put the young Price Sulaiman, son of the murdered Abdul Jalil, on the throne.

The voc was increasingly being hindered by the Bugis. They disturbed trade, broke the monopoly, and piracy was on the increase. In 1745 the junior merchant Claas de Wind was sent

Above: Drawing of flags of the ships conquered by van Braam.

with the schooner *Lijdzaamheid* to Sultan Sulaiman of Johore to complain about the pirates who, as it was put, 'with many vessels to the north and south of here deter traders and without the least payment violently take their merchandise and eatables, under pretext of their own need, which causes excessive price rises ... and these robbers, in broad daylight and in sight of the cannon on the walls attack the fishermen and rob them.'

The complaints had no effect, and subsequent punitive expeditions were met by fierce battles. The Bugis extended their power, and in 1757 they landed just outside Malacca. They inflicted much damage to the outlying parts of the city and even threatened to lay siege to the city. Only months later reinforcements arrived

from Batavia in the form of six ships and two hundred soldiers, which reduced the Bugis threat. However, around 1783, the Bugis again threatened Malacca. This time a Dutch squadron under van Braam defeated them convincingly, and brought about the expusion of the Bugis from Johore.

The Bloodbath of Siak

In Siak the voc also had great problems to contend with; the small voc fort on Pulau Gontong, just off the coast, was even lost. The garrison on Pulau Gontong was led by Ensign Hansen. On November 6, 1759, Raja Mohammed of Siak approached with forty vessels. The raja sent Hansen a costly gift consisting of two barrels of arak, five bags of rice, four bags of *kajang* (peanuts)

Below: 18th-century weapon, with a lock cast after an European example. Such guns were used by the Bugis and other local warriors.

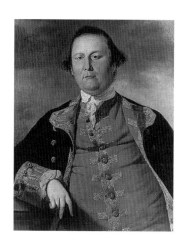

and two packs of Javanese cloth. The innocent ensign received the ruler and his heavily armed retinue with gunfire salutes. After the usual ceremony, the raja was allowed to bring in another fifty men armed with krisses. Barely inside they drew their weapons, murdering almost the entire garrison in cold blood. The fort was pulled down and the cannon were carted off. Ensign Hansen was one of the dead. And that was a good thing, the governor of Malacca wrote bitterly, 'because otherwise he would not have been able to avoid an exemplary and most vigorous and even shameful punishment for his conduct in this affair'.

It was just two years later that the VOC was able to equip an expedition led by Jan Janszoon Visboom to repair the fort. The sailors shuddered at the sight of the bones and other evidence of the murder of their colleagues and hurriedly rebuilt the fort. The enemy was not inactive either. They organized themselves upstream on the river and terrorized the population to prevent them from choosing the side of the Dutch. They were well-armed and possessed the *kota bejalam*, a floating fort. This vessel 'looked like Noah's ark in the Bible picture book', Visboom wrote, 'except that there were portholes for twelve-pounder cannon'. The Dutch soldiers were continuously coming under rifle

Above: Portrait of Jacob Pieter van Braam (1737-1803), commander of the VOC squadron that fought the Bugis.

Below: Battle between van Braam's fleet and the Bugis in 1784.

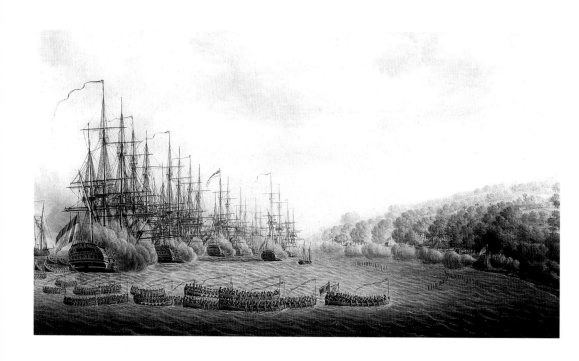

fire. 'On June 2, at two bells of the second watch, eleven robber fireships came down and made a terrible fire and occupied the whole breadth of the river, as they were tied together.' Miraculously the fireships floated on through the Dutch ships. Besides shooting there was also shouting. 'Also on this evening (June 13), the dogs cursed us in good Dutch and in Malay', we read in Visboom's report. That cursing in Dutch probably came from the seaman Lambert Geyzoon and the soldier Antonie Kramer, both of whom had defected. On June 15 a small raft came floating up with a red and white pennant on which was written in Malay that 'if we did not pray their God Mohammed for mercy, we would all be burned and spread as chaff in the wind or be cut to pieces'.

After waiting in vain for reinforcements, Visboom decided on the evening of June 16 to attack. The first officer and some sailors were able to cut the logs tied together with rattan which blocked the river, for which they received a reward of thirty Spanish reals. The Dutch then went upriver and such a violent battle ensued that the Dutch soldiers had to 'shout from the ships and vessels, so that the enemy would not hear the groaning of our wounded'. After a furious battle the Dutch emerged as victors, having lost

Below: The burning of a Bugis' stronghold on the Johore coast by van Braam's troops, 1784.

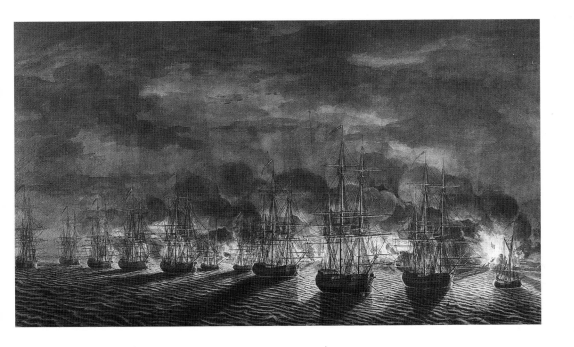

The British

Freeport Penang

For some time the British East India Company had been trying to establish a base in South-east Asia, but with the exception of relatively insignificant Bencoolen, a pepper port on the West coast of Sumatra, had not been successful in doing so. Still, Bencoolen was a thorn in the side of the Dutch East India Company. In the second half of the eighteenth century the need to gain footholds in the region became more urgent for improved links with the Indonesian archipelago and China. Improved control of the Bay of Bengal required a naval base in Malaya or Siam. The introduction of East Indiamen, large ships which maintained the trade between China and India, resulted in the desire for a British port where the ships could put in for supplies or repairs, instead of having to be dependent on VOC ports such as Malacca.

In about 1770 the British got a chance: Sultan Muhammad of Kedah sought British help against Siam and the Bugis, who constantly threatened his country's souvereignty. In addition, Kedah from time to time had to pay levies to Burma. The young British naval officer Francis Light happened to be on the scene — Light sent enthusiastic letters to Madras, the nerve centre of the British East India Company about the possibility of British intervention in Kedah and the establishment of a base on the island of Penang off the coast of Kedah. The outbreak of the Fourth Anglo-Dutch war in 1780 gave an impetus to Light's plan: the Dutch had become enemies and Malacca a hostile port. After negotiations with Abdullah, Sultan Muhammad's young son, Light formally took possession of Penang on August 11, 1786, and renamed it Prince of Wales Island. The town which was built along the

Left: The Singapore River and harbour in about 1850.

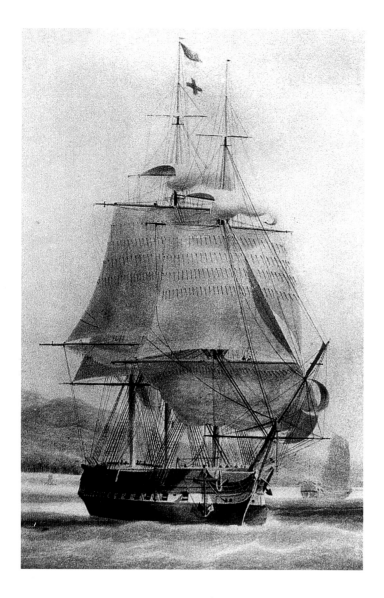

Above: The three-master *William Fairlie* leaves the harbour of Penang. Detail of a painting by William J. Huggins, 1818.

island's natural harbour was christened Georgetown, after King George III. However, the British occupation of Penang was minimal, to the disappointment of both Light and the sultan. After five years had passed, the Sultan realized he would receive little help against his enemies and decided he wanted Penang returned to him. However, an attempt to drive out the British with a fleet of two hundred boats failed. The Sultan of Kedah was forced to sign a treaty by which he and his successors were to be paid six thousand dollars annually for the use of Penang. Later, when the British took possession of a stretch of coastline facing the island,

this amount was increased to ten thousand dollars. Francis Light turned Penang into a freeport where everyone could trade or work the land. The population grew from only one thousand in 1784 to twelve thousand in 1804 and consisted of Malays, Indians, Chinese, Arabs, Bugis, Siamese and Europeans. In addition, thousands of traders visited the island on a regular basis, particularly Arabs and Bugis. Good friends but dangerous enemies, was Light's opinion of the former, while the Bugis he said were an independent, proud and warlike people. The Malays on Penang were mainly engaged in forestry and rice farming. The Indians, mainly from the Coromandel coast, were shopkeepers or coolies. Light reported that the Chinese were the hardest working inhabitants of Penang; there were more than three thousand men, women and children, he wrote, and they had occupations such as that of carpenter, bricklayer or blacksmith. The Chinese also owned ships and sent merchantmen to neighbouring countries to trade. The British East India Company's directors ignored Light's pleas to establish an orderly administration on Penang, so that Light was obliged to administer the island by himself.

Letters from Kew

The year 1795 brought a sudden change to the colonies. French revolutionary armies under general Pichegru invaded Holland across its frozen rivers and occupied much of the country. The Dutch Stadtholder William V of Orange fled to England and it was from Kew, a London suburb, that he wrote his famous 'Kew

Below: The harbour of Penang in 1837.

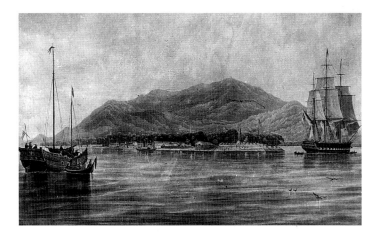

Above: A Malay coastal village in Penang.

Letters'. In these letters the administrators of the Dutch colonies were ordered to hand over the territories under their control to the British to keep them from falling into the hands of the French. Governor Abraham Couperus of Malacca had no difficulty with William's order. When a British fleet appeared off Malacca, the city was delivered to them without further ado. The inhabitants of Malacca did not understand at all: for all they knew the British were the archenemies of the Dutch and, fearing a great battle, thousands of them had fled into the surrounding forests. They returned hesitantly. The government in Malacca was less than happy with Couperus' quick decision. The Fiscal even held an enquiry from which it appears that many Dutch East India Company civil servants and soldiers did not agree with their governor. Unsurprisingly, the British transported most of them to Madras. There was a rumour that Couperus had been attacked in the street because of his 'treason' and that he and his family had been smuggled aboard a British ship to be taken to Madras as well. Various eyewitnesses even stated that Adriaan Koek, Couperus' brother-in-law, had hung lanterns in his plantation to show the British the way in the dark night. During the British interregnum Couperus became president of the Court of Justice in Surabaya. It was only years later that he had the opportunity to defend himself, and he maintained that he had acted on orders of

the stadtholder and was able to present as evidence a letter by a British officer.

The arrival of the British in Malacca was certainly not to everyone's liking: for some time, merchants were forced to sell their wares to the British at ridiculously low prices. But later the British policy of free trade started to yield good profits. The strict Dutch trade monopoly regulations were thrown overboard. For the rest not much changed. The British adopted almost all the Dutch East India Company administrative regulations, with the exception of punishments. The British Governor Farquhar paid a visit to *Misercordia*, the Dutch prison inside the fort. He saw the *terongko selap* (dark chamber) where the most severely sentenced prisoners were kept, witnessed the *teratu* (torture chamber), packed full of terrible instruments such as branding irons, a nail-pierced barrel in which prisoners were rolled over the streets, benches on which bones were broken, thumbscrews and many other hellish tools. Farquhar had the torture chamber emptied and

Below: Malacca in 1807, during the British interregnum; the square in front of the *Stadbuys*.

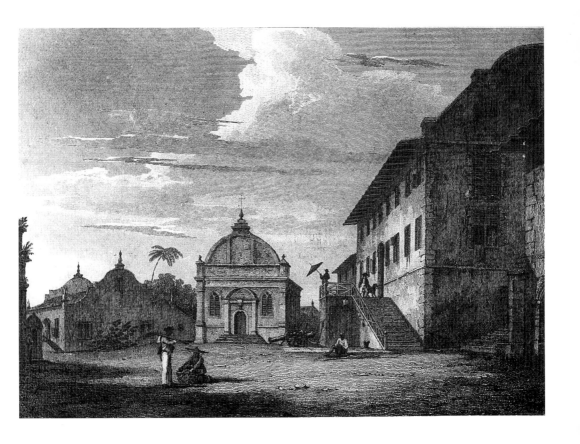

all instruments were either burned or thrown into the sea.

Malacca Dismantled

When the British occupation of Malacca started lasting longer than people had expected, the inhabitants of Penang started to worry about the competition from Malacca. It was feared that the Dutch, on their return, would have an advantage. Partly because of this it was decided to dismantle all fortifications in Malacca so that the port would permanently lose its strategic importance. A small army of labourers went to work, but the walls were so strong that they were proof against the heaviest sledgehammers. Digging up the foundations did not work either because the walls were deeper than they were tall. In the meantime stories went around the demolition teams about mysterious powers and ghosts in the walls which made the workers ill and even resulted in the deaths of some of them. In spite of double pay, many of them refused to work at the fort any longer. Finally Farquhar decided

Below: The Malacca River in 1807.

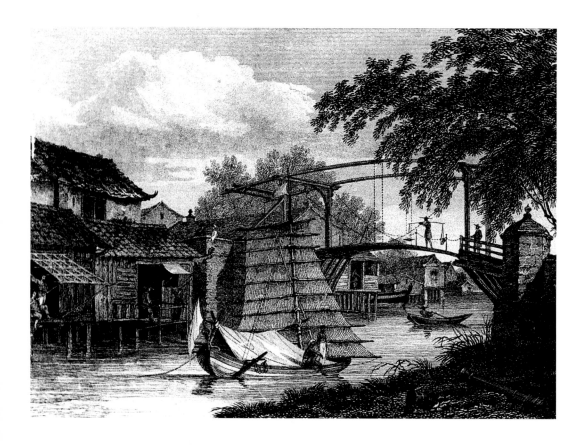

on stronger measures. He had gunpowder charges placed and then he had the town evacuated. The governor himself lit the fuse and then spurred his horse to get away. There was a terrific explosion, pieces of wall were blown apart, shards of stone flew over the river and damaged houses. Some people who had concealed themselves near the fort paid dearly for their curiosity. One was killed and two were severely wounded. The rest of the fort was then destroyed with weaker charges. The stone was used for building houses. *A Famosa*, the pride of Malacca, was no more.

Governor Farquhar

In contrast with many earlier colonial administrators, who had had a cold disdain for subjected nations, Farquhar had a warm interest for the people, and flora and fauna of Malaya. His house was full of animals: birds in cages, a leopard on a chain and monkeys roaming freely. A tiger found as a cub was put in a cage outside when it became too big to be kept indoors. The inhabitants of Malacca would regularly come have a look at the nervously pacing animal. When it became an adult, the tiger managed to heavily damage its cage. A Chinese carpenter who was to repair it was mauled so badly in the face that he lost an eye. Farquhar then had the animal shot and stuffed. One day an elephant catcher came to pay his respects. With Farquhar's permission he built a gigantic elephant trap in the jungle outside Malacca. After a drive which lasted for days he managed, with dozens of helpers, to get a herd of sixty elephants into the enclosure. The news of this catch made the entire population of Malacca come out and see. People thronged around the enclosure, climbed on the walls and gawked at the nervously trumpeting milling animals. The elephant catcher tamed them by starving them until they were so weak he could chain their legs. The animals were then subdued by rewarding them with small bits of food. In the end, of the sixty elephants, only one arrived in Malacca alive. The tusks and bones of the dead elephants were sent to England for scientific purposes. Farquhar was very popular, and his interest in Malay customs was much appreciated. People felt more free under his administration than they had felt under the yoke of the Dutch East India Company. When the governor went out for his daily ride on horseback or in a carriage he would receive many polite greet-

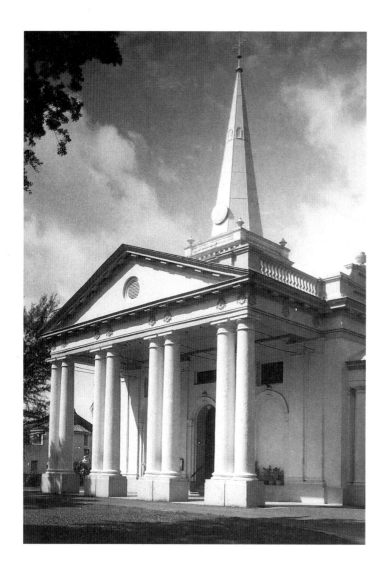

Above: St George's Church in Penang built in 1818; the first Anglican church in South-east Asia.

ings. After an incident during one of these rides, in which the governor went out to the jungle and was attacked by a tiger and only suffered a lost hat, many believed that he possessed supernatural powers.

Less appreciated were the morals of the British men; when a ship anchored, doors and windows were closed and the women stayed home, fearing the British who would drunkenly grope the women and fight the men.

Raffles

In 1805 Francis Light's pleas were finally attended to, and Penang received status comparable to that of Madras or Calcutta. A complete administration was installed with dozens of civil servants. Among them was the promising young civil servant Thomas Stamford Raffles, who quickly rose to become secretary of the council. But Raffles worked so hard that he had to be sent on sick leave. He chose Malacca as the place to recuperate. Raffles' interest in history, literature and natural history surpassed even Farquhar's. He employed four men who did nothing but collect insects, plants, shells, butterflies and birds for him. These were dried, stuffed or bottled. Once Raffles was even sent an orangutan from Borneo, which roamed his house dressed in a hat and coat.Right and left Raffles bought ancient and unique manuscripts so that he soon possessed a library of hundreds of works and therewith more or less the entire Malay written culture. He also asked Farquhar to stop further demolition of Dutch East India Company buildings.

Above: Thomas Stamford Raffles.

Below: A Dutch-style house in Malacca.

Right: The Dutch ships *Wilhelmina* and *Tromp* at Malacca during the take-over from the British.

The caption of this drawing reads in translation: '*Malacca taken over from the British administration of resident Farguehar by the commissioners Wolterbeek & Timmerman Tijssen on 21 September 1818*'.

After the Anglo-Dutch Treaty of 1824, Malacca would again become British.

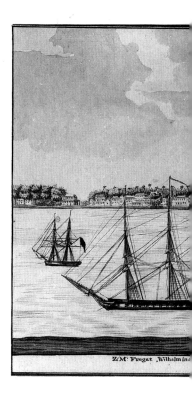

The Conquest of Java

In the meantime Java was still in the hands of the Dutch. It was governed by Herman Willen Daendels, the 'thundering marshal', exiled from Holland in 1787 because of his pro-French leanings and gloriously returning in Pichegru's army. The British decided to take Java. To this end, a large fleet was assembled in Malacca. One company after another marched into the town to the sound of drums, fifes and bagpipes. The inhabitants of Malacca were amazed at the trained young bulls pulling the cannon and the immaculately drilled cavalry exercising daily on the surrounding hills. The demand for supplies for the immense camp raised food prices astronomically, to the satisfaction of the traders who thus tended to overlook any trouble caused by the British presence. The soldiers stood to attention in long rows, gun salutes made the air vibrate, colourful uniforms and brilliantly polished weapons gleamed and glittered. Shortly afterwards the fleet set sail and Java was occupied by the British. Raffles was appointed governor of Java, during which period he wrote his famous 'History of Java'.

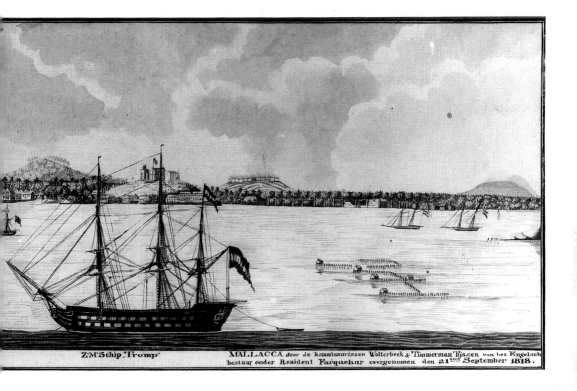

Z.M.Schip "Tromp"

MALLACCA door de kommissarissen Wolterbeek & Timmerman Thyssen van het Engelsch bestuur onder Resident Farquehar overgenomen den 21ste September 1818.

The Return of the Dutch

After the defeat of the French in Europe and the Treaty of Vienna in 1815, where the European powers — wishing to forestall new French attacks — had put aside old differences and formed an alliance, the Dutch had their colonial possesions returned to them, including Malacca. On September 21, 1818, the Dutch formally returned to Malacca; Governor Timmerman Thyssen ceremonially took possession of the remnants of the fort. To the sound of drums and bugles the British and Dutch flags were raised and lowered, and in the end only the Dutch flag remained at the top.

Singapore

After Java was also returned to the Dutch, Raffles spent a brief spell in London, after which he returned to the east as governor of Bencoolen on Sumatra. He was concerned with the possibility of the Dutch taking possession of all the Malay peninsula, and began to plan how he could bring about British colonization instead. He wrote to the British East India Company and contacted his friend Farquhar who had had to give up his governorship

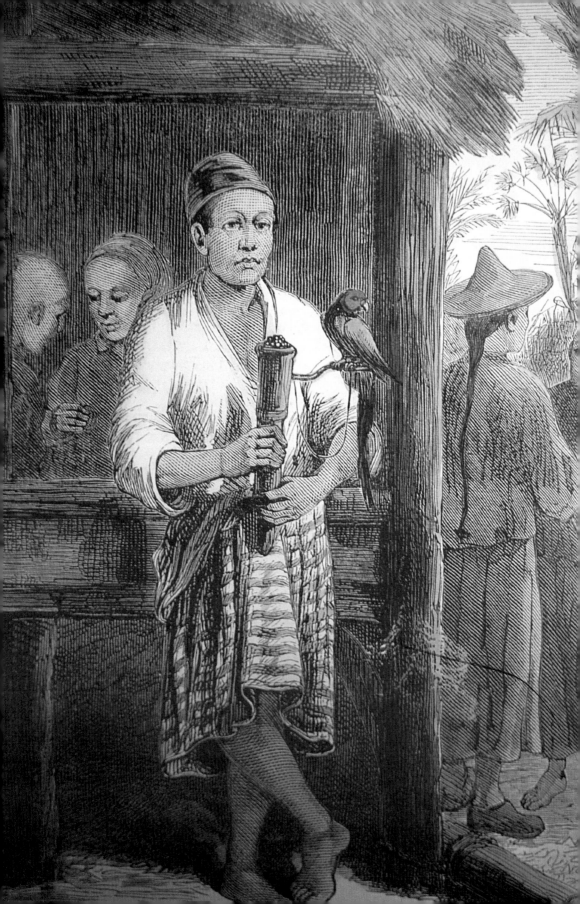

of Malacca to the Dutch. Raffles understood the need for a port in southern Malaya, now that Java was no longer British. Riau was excluded because the Dutch were already there and so his attentio fell on the island of Singapore, just off the Johore coast. On January 29, 1819, Raffles, accompanied by Farquhar, set foot in Singapore. The island was grown over with myrtle bushes and rhododendrons. There were some small Malay settlements of *atap* (palm leaf) huts, among these was one populated by *orang laut.* In a larger dwelling there lived a local headman, the *temenggong,* who owed fealty to the Sultan of Johore. Among the Malays, the island was called Tumasek in those days.

There was little agriculture in Singapore, but the location was very suited to shipping. Raffles was surprised that these possibilities had not been discovered earlier. To a friend in England he wrote that there was no place with more advantages: it was a week's sailing from China and even closer to Siam and Cochin, and it lay in the heart of the archipelago, or, as the Malays say, in

Left: Malay and Chinese traders in Singapore on a 19th-century engraving.

Below: Chinese settlement in Singapore.

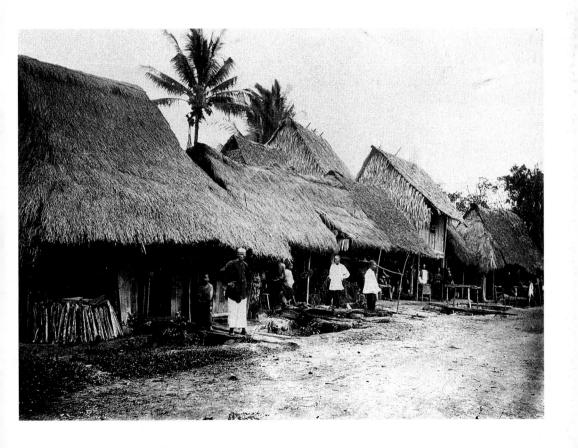

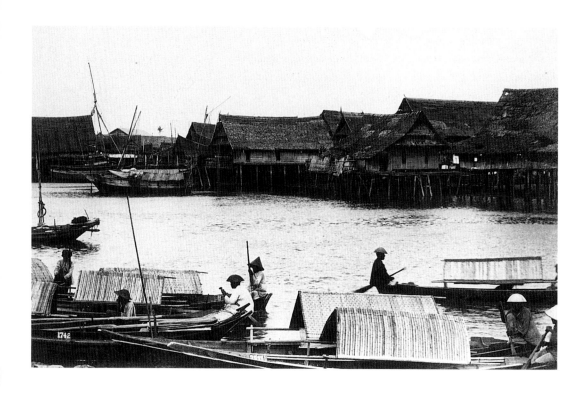

Above: *Kampung Bugis* (Bugis Village) in Singapore. The huts were built on stilts in the water.

the Navel of Malay lands.

Raffles and Farquhar paid a ceremonial visit to the *temenggong* and announced the purpose of their visit. The *temenggong* agreed to cooperate if the sultan approved. This was a complex situation because the old sultan had died and in the absence of a legal heir two sons of concubines were fighting for the throne. In the end an alliance was concluded with one of them, Tengku Hussain, and this sultan settled in Singapore and, like the *temenggong*, received a monthly payment.

The Dutch were not in the least pleased with Raffles' actions. There was much diplomatic correspondence between Batavia, London, The Hague and Calcutta, which yielded the Anglo-Dutch Treaty of 1824. This treaty virtually meant a division of the entire Malay archipelago between the Dutch and the British. A boundary line was drawn through the Straits of Malacca, with the Dutch keeping control over Sumatra and the British over the entire Malay peninsula. To this end, Bencoolen and Malacca were exchanged. All territories south of Singapore were to be Dutch, so much of the present border of Indonesia was established. Great Britain retained its possessions in India.

The British possessions in the Straits, now consisting of Penang, Malacca and Singapore were first administered from Penang but when that proved too expensive, they were placed under the British government in India in 1832. From that moment on the British termed their possessions in Malaya the 'Straits Settlements'.

Explosive Expansion

In the meantime Singapore kept on gaining in importance. In 1820 it already had a population of ten thousand. Traders from all parts curiously came to the port and quickly understood that it represented an excellent opportunity. People in Penang and Malacca were unhappy with the expansion of Singapore. In Malacca especially, the old prosperity never returned, so that the merchants no longer made much profit. Many sought their livelihoods in Singapore by going to work there. In Singapore there was always a demand for labourers, food and raw materials. Initially, houses in Singapore were not much more than huts covered with *atap*. But gradually land was cleared, and the town expanded according to accurate plans. The swampy banks of the Singapore River were packed down and flattened.

The population consisted of a mix of mainly merchants, adventurers and fortune seekers from many races and walks of life. Some of them lost large sums very quickly, others who had come

Below: A Malay shipbuilder.

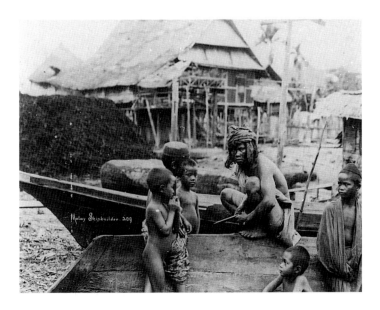

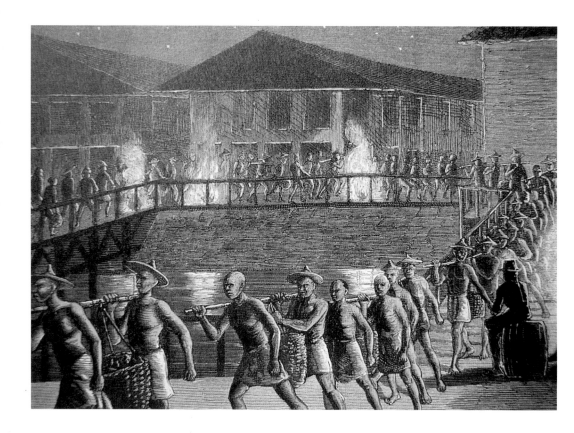

Above: Coolies emptying a ship in Singapore.

penniless were quickly rich.

One distinct shortage in Singapore was that of women. Arab merchants saw their chance and brought in loads of female slaves from Bali and Africa. This merchandise, which would be extolled loudly and with obscene gestures, found a ready market. When complaints about this reached Raffles, he referred to the discussions about slavery in the British Parliament: only after the abolition of slavery could something be done about it.

Precious Possession

Rapidly expanding Singapore brought in profits mainly through the China trade, but when, in 1833, the British East India Company lost its monopoly on this trade, the Straits Settlements ceased to yield profits. The colonial government in India was reluctant to extend British influence to the interior of Malaya, in spite of pressure from London to subjugate the whole native population.

However, step by step measures were taken to increase British

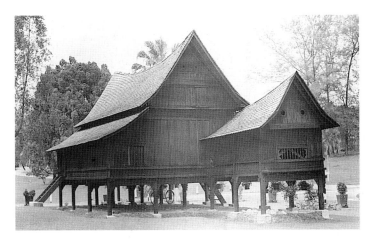

involvement in the affairs of the peninsula. In 1826 the Anglo-Siamese Treaty was concluded, which guaranteed the status quo on the border between Siam and Malaya.

And the British were not able to escape further involvement. The Nanning War is one notorious example of that. Then Governor Robert Fullerton considered an area close to Malacca, which was mainly inhabited by Minangkabau, to be part of the town. The native district chief did not agree. A series of succession troubles and a refusal to pay taxes did not improve the situation, and the British decided to take tough measures, which resulted in the

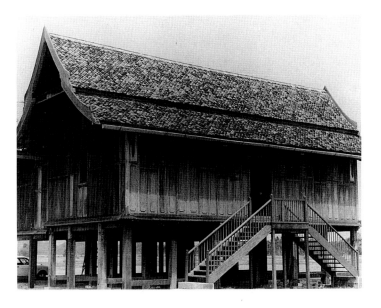

Above: A group of Malays in front
of a 19th-century timber mosque
in Muar, near Malacca.

Nanning War of 1831-32, which the British ultimately won.
Also, the continuous problem of piracy in the Straits of Malacca
was one the British could not avoid. Traditionally, for the sultans
and other local rulers, piracy was a right acquired by the *orang
laut*. With food and weapons the Malay rulers bought the pirates'
loyalty and a share of the booty. From the coast with its many
islands and coves the pirates attacked the eastbound or west-
bound merchantmen, depending on the prevailing monsoon,
forming a constant threat, especially in the area between
Singapore and Malacca. Captured crews were killed or used as
rowers on the swift and manoeverable pirate ships. The British
decided to put an end to the piracy, mainly because of the dam-
age to trade. They were supported by groups in Britain who
wished to stop piracy for humanitarian reasons. Heavily armed
steamers with modern weapons were used against the pirates;
regardless of the wind, steamers could pursue the pirates to their
lairs and finish them. Treaties were concluded with the sultans
who received compensation for their lost income. In about 1870
piracy had largely disappeared.
Throughout the 19th century, the interior of the Malay peninsula

remained fairly inaccessible. The population lived along the rivers, which were the principal means of communication. All imports and exports were transported along the rivers. Kampongs (villages) consisted of houses with simple roofs of *atap*; the main buildings would be the mosque and the house of the *penghulu* (village headman). In larger settlements there might be a *temenggong*'s residence, and in state capitals a sultan's palace. From time to time there were legendary 'wars' because of the succession in the often complex hierarchy of sultans, *temenggongs* and *bendaharas*. After skirmishes between the various parties a new ruler arose and there was peace for a time. The sultan stood above everyone else and represented the symbol of the unity, he alone had the power of life and death.

The sultans were surrounded by ritual and maintained large households. Their income would consist of tolls and taxes, and, in addition, farmers and fishermen would regularly perform feudal duties for them.The population was divided into two strata: the nobles by birth, and the *rakyat*, consisting of workers, farmers and fishermen. In some states, especially those along the east coast of the peninsula, there were also large groups of artists and craftsmen, who would work under royal patronage. The *rakyat* often owed money to the nobility. A farmer could for example borrow money from a village chief and then work off his debt. In this system it was virtually impossible for a man from the *rakyat* to escape from his class, while the sultan and the nobles were always assured of food, money and free labour. This situation continued for centuries until outside influence totally altered the economy.

Miners

Interest in the interior of Malaya began growing when, in the West, a large demand for raw materials arose such as *guttapercha* and tin. *Guttapercha* — an English rendering of the Malay *getah pertjah*, the gum of the *pertjah* tree — had been known in Malaya since the 17th century. It was used to make things watertight and was taken from cuts in the bark. In 1845 it was discovered that *guttapercha* was eminently suitable to insulate undersea telegraph cables. The demand grew to such an extent that the tappers did not take the time to extract the gum in the traditional manner, but cut the trees and cut them open to get all the gum at once. The

Above: Tin mining.

result was that the *pertjah* tree almost became extinct.

Tin had long been Malaya's premier export commodity, and was excavated primarily in the states of Perak and Selangor. It was mined according to the *lampan* method. First a river valley was selected. Tin-bearing dirt was loosened with pickaxes and thrown into the water, where the dirt washed away and the tin ore remained. In the course of the 19th century, demand for tin became so large that new tin fields were constantly sought in Malaya. The success of tin mining gave rise to the founding of many new settlements, of which Ipoh in Perak and Kuala Lumpur in Selangor would eventually grow into principal cities.

The exploitation of the tin mines was almost wholly in the hands of the Chinese. Although Chinese had been emigrating to South-east Asia for centuries, their actual number in the peninsula had been limited. In 1820 there were no more than 12,000 of them, mainly in Penang, Malacca and Singapore. But conditions in China were changing. Dissatisfaction with the ruling Manchu dynasty led to the Taiping rebellion, followed by civil war. Also, there was much resistance against British diplomatic efforts to get a firmer grip on the China trade, leading to conflicts such as the notorious First Opium War which broke out in 1839. The Chinese Emperor wished to eradicate the mass British imports of opium from India to Canton, which led to large-scale opium addiction in China. But

the interests involved in this profitable business were too power-
ful. All the unrest in the country made many Chinese decide to
emigrate. In 1860 thousands of Chinese had settled in Malaya,
including many who had found work as farmers or miners in the
interior. The Chinese traders who controlled the new tin mines
got a free hand in exchange for taxes paid to the local sultans.
The Chinese labourers usually received free passage to Malaya,
which they were required to work off during a set period of time.
After that they could begin earning for themselves. Often these
were frugal people, saving money to send to their families, and
some were able to save and borrow enough to set up in trade.
Others, however, lost their hard-earned money in the gambling
houses or in cockfights or spent everything at festivities such as
the exuberant Chinese New Year. Most of them lived impover-
ished lives in the malaria infested jungle of the peninsula, full of
illness and deprivation. Often enough, mortality rose to more than
fifty percent, and new labourers were brought in. In time the
Chinese developed more efficient methods of mining, making use
of all their inventiveness and ancient tools. Ingenious systems
were developed with chain pumps, water wheels, gutters and
bamboo pipes.

Chinese Societies
Much of the strength of the Chinese lay in their organization.
Family clans and *kongsis* formed the basis of this. *Kongis* are
associations based on kinship or geographical ties. Kinship would
often be claimed solely on common surname, and not necessarily
on common ancestry. Apart from social functions, kongsis also
played important roles in business. For example, a merchant
would lead members of a *kongsi* to work on a project in a strict
hierarchy. All would share profits as well as losses.
Much influence within the chinese communities was reserved for
the so-called Secret Societies. The history of the societies is large-
ly unknown because members are sworn to total secrecy.
Breaking this oath meant death. Nevertheless it is known that the
societies had extensive initiation rites. There were secret signs,
and members could recognize each other, for example, by order-
ing ordinary objects in a certain way. The secrecy surrounding the
societies and the absolute loyalty and mutual support of their
members, and not least the rivalry between societies that could

The Need for Female Immigrants
*In his description of the Chinese
in the Straits Settlements, J.D.
Vaughan observed that it would
be wise to encourage the immi-
gration of Chinese women: the
presence of women would be of
great importance to peace in the
colony. The Chinese, he said,
were domestic in nature, and
when ringed by wife and children
they would strive for order and
peace; they would, Vaughan said,
not be as easily incited to riot as
when their family ties would pre-
vent them from doing so.*

祖德龍光
遠芳規萬
世明追思
詮旨在吾
肇奉奎型
時維戊辰年

Above: Decoration in the form of an inscribed scroll on a Chinese house in Malacca.

Right: Chinese festival in Singapore in 1840.

lead to outbursts of violence, led to jealousy and suspicion on the part of outsiders.

The sultans as well as the British left the Chinese alone, until political differences between the Chinese started manifesting themselves in riots and murder. In 1867 in Penang, for example, there were serious outbursts of violence, and order was only restored with great difficulty. The situation became more dangerous when the various Chinese groups became involved in the usual succession conflicts, and the control over tin-rich territories. Fighting units of the various secret societies took part in armed conflicts between Malay factions, which eventually culminated in civil war in Selangor and parts of Perak and Negri Sembilan. These Chinese fighters dressed in cotton and walked on straw sandals. Their weapons were swords, daggers and occasionally a rifle. Folded skins worn over the chest and coconut helmets provided personal protection. The simplicity of their armament was offset by their numbers and their zeal.

Access to the Interior

As the 19th century wore on the British changed their non-interventionist policy in the Malay peninsula. In 1858 the British East India Company was abolished, which meant that the company's colonial holdings were transferred to the British government. In

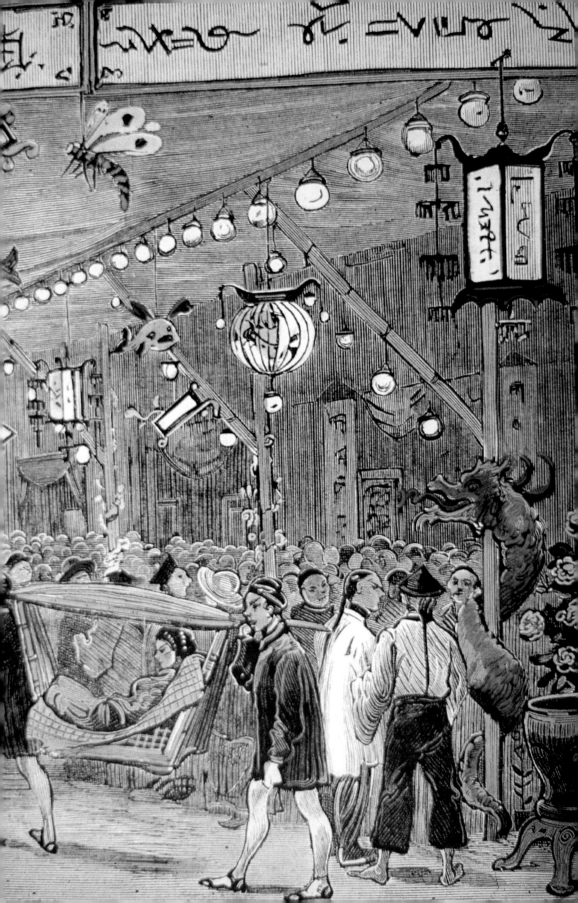

Above: Carriages on a plantation in Malaya.

1867 the Straits Settlements were declared crown colonies, and came under direct administration of the Colonial Office in London. This made lobbying easier for the proponents of complete colonization. The completion of the Suez canal in 1869 shortened the distance between Britain and the Far East, which made the import of raw materials from, among others, Malaya more attractive.

Furthermore, the unrest in Perak and Selangor formed an immediate threat to the business interests of the British companies in Penang and Singapore. Tin prices were constantly rising, but the supply was often in danger due to the continuing conflicts.

And, lastly, there was the important consideration that if the Btitish would not control the peninsula, the Germans or the French might attempt to expand their influence.

Residents

Despite the growing economic importance of the Malay interior, there was resistance against establishing an extensive administration. Also, it was understood that an aggressive approach to bring the region under British control would not ensure the cooperation of the indigenous poulation. A solution was the system of indirect

rule introduced in Nigeria by Lord Lugard. Lugard attempted to introduce British ideas indirectly by way of local chiefs and existing channels. This principle was adopted in Malaya. After negotiations it was agreed in 1874 that Perak and Selangor would accept the installation of a British 'resident', followed by Negri-Sembilan in 1885 and Pahang in 1887. These residents had the task of introducing British administrative systems within the framework of existing customs and religion. Officially the sultans were left in control, the status of the residents being that of adviser. In reality the residents assumed much more responsibility and power; only the issues of traditional customs and Islam were left entirely to the sultans. However, customs were so interwoven with daily life that attempts to alter social and economic relations infringed upon them. A resident therefore needed to have considerable amounts of patience and wisdom to find a position that served British interests and at the same time ensured the cooperation of the sultans and local population

Because of their interest in the people, language and culture, various residents managed to fulfil their difficult task successfully. In Perak, however, things went wrong. James Birch, Perak's first resident, proved to be unsuited for his job. He barely spoke Malay, had no interest at all in court rituals, and disapproved of the ingrained custom of debt slavery. As a result, Birch did not gain the respect of the local people, and, worse, he made Sultan

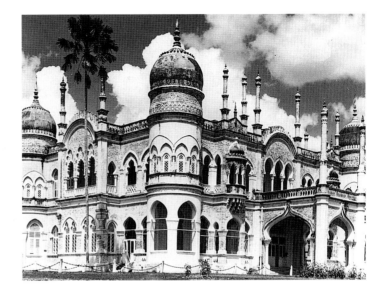

Below: The 'Moorish style' palace of the Sultan of Selangor, built by the British in the late 19th century, in Klang.

Abdullah lose face as a result of his actions. A dramatic finale took place on a November morning when the resident made his way to a palmleaf bathhouse in the river. A group of men approached threateningly and started tearing British proclamations off a Chinese shop. Tempers flared and shouting '*amok*', the men ran towards the bathhouse. Spears penetrated its thin walls, Birch was struck in the head by a sword and the mortally wounded resident disappeared in the current. The British expected severe civil unrest in Perak, and soldiers and marines from India and Hong Kong were brought in. Heavily armed troops, prepared for massive popular resistance, marched into Perak. But there was no resistance at all: the source of all aggravation, the tactless resident, had been removed from the scene.

Kuala Lumpur

Within the state of Selangor there were a number of rivers, of which the Klang River was the most important, as large deposits of tin were found upstream. In 1857 the ruler of the Klang valley, Raja Abdullah, brought in a group of Chinese immigrants to set up large scale tin mining along the Klang River. This proved to be highly successful, and increasing numbers of miners were brought in. The farthest point along the river that could be reached by

Below: Kuala Lumpur in about 1880.

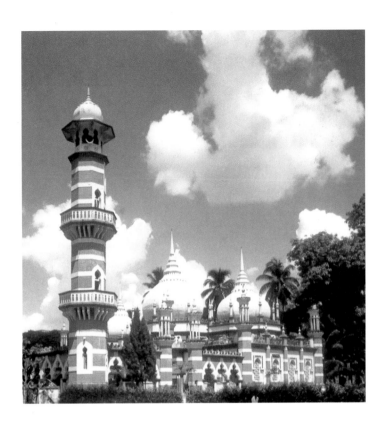

boat was at the point where the Gombak River joined the Klang, and it was here that a first trading post was set up. Around this trading post, and further to the direction of Ampang a settlement grew which became known as Kuala Lumpur. Roughly translated, this name means 'muddy confluence', referring to the joining Gombak and Klang rivers, which is a muddy place indeed. This occurred at a time when civil war was raging in Selangor; Raja Abdullah's rights over the Klang valley were disputed by other rajas, and infighting among the various Chinese dialect groups and secret societies was rife.

One of the most notable Chinese in this troubled period was Yap Ah Loy. 'temperamental and as strong as an ox', as legend has it. He was born in 1837, in Kuantung in China and came to Malacca as an 18-year old where, as usual, he was taken in by relatives. After an unhappy start as shop assistant at a tin mine, he was courteously advised to forestall homesickness by going home. He did not get further than Singapore, gambled away his money, and ended up in Kuala Lumpur in 1862. He first went to work as a cook at a tin mine. By saving his wages, setting up a profitable

Below: The Jamek Mosque in Kuala Lumpur. Its location is exactly at the confluence of the Gombak and Klang rivers.

Right: Yap Ah Loy, *Kapitan Cina*
of Kuala Lumpur from 1868 until
1885.

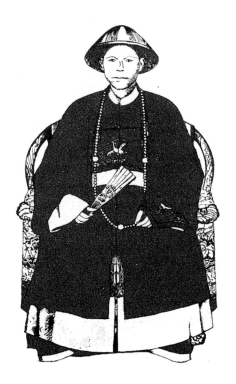

trade in pigs, and speculating well, he quickly worked his way
up. Yap Ah Loy built up such a good name that the first *Kapitan
Cina* of Kuala Lumpur designated him as his successor. His offi-
cial installation in 1868 was an event for which the tin miners
came from near and far. The settlement was decorated with
lanterns, and on the market place a pagoda with an altar had
been set up as well as sheds for the guests. There was free food,
and especially drink, for everyone.

Yap Ah Loy started by introducing stricter law and order.
Apprehended thieves had to carry their loot through the streets in
broad daylight. On the second offence an ear was cut off and the
third was punished by death — this sentence was carried out by
sticking a sword in the offender's throat. A gaol was built with a
capacity of sixty inmates. Under Yap Ah Loy's rule, Kuala Lumpur
experienced much unrest. The town became heavily involved in
the territorial conflicts between the warring rajas and was even
besieged for a long time in 1870. Despite these difficulties, Kuala

Lumpur kept on growing, and in 1880 the British authorities in Selangor decided to move their resident's administration from Klang town, at the mouth of the river, to Kuala Lumpur.

Yap Ah Loy fell ill and died in 1885, just as he was preparing a voyage to China.

Above: Petaling Street in Kuala Lumpur in the late 19th century.
Below: The Selangor State Government Building in Kuala Lumpur under construction.

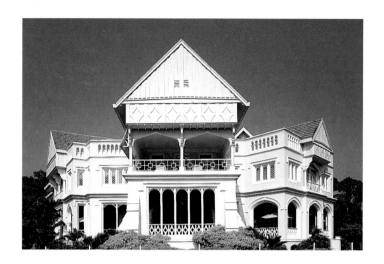

Above: The official residence of the resident-general of the Federated Malay States in Kuala Lumpur. Swettenham named it *Carcosa* (dear object). After independence, the building became the British High Commission to Malaysia, and in the late 1980s it was renovated into an exclusive hotel.

The Federation

After the Birch incident, peace returned to Perak, not least because of the intelligent policies of the new Resident Frank Swettenham, who had a good knowledge of Malay customs and traditions, and spoke excellent Malay. Swettenham advocated more efficiency in the administration of the states under British control. He became the instigator and first Resident-General of the Federation of Malay States (FMS) of 1896, consisting of Perak, Selangor, Negri-Sembilan and Pahang. Kuala Lumpur was chosen as the capital of the FMS. In 1897 the sultans of these four states met for the first time in what became known as the Rulers' Conference, a practice that continues today.

In 1904 France and Britain agreed to a common policy against German colonial ambitions. This led to a treaty with Siam by which Britain gained possession of the northern Malay states Terengganu, Kelantan, Kedah and Perlis in 1909. In return, the British financed the construction of a railway in southern Thailand.

In the meantime, the Sultan of Johore had maintained close relations with Singapore, and in 1914 this state was also officially included in the British sphere of influence. The British now controled the whole Malay peninsula, although in a haphazard way: Singapore, Malacca and Penang were united in the Straits Settlements (of which Singapore was now the capital); Perak, Selangor, Pahang and Negri Sembilan formed the FMS; and Perlis, Kedah, Kelantan, Terengganu and Johore were known as 'the

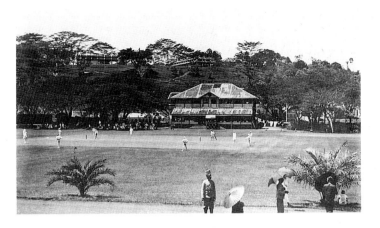

Left: Cricket match in progress in front of the Selangor Club in Kuala Lumpur.

unfederated Malay states'. The only exception to British rule was the Malay state of Patani, which became an integral part of the Kingdom of Siam.

What the British had originally wished to avoid now happened. Hordes of civil servants travelled to the interior, followed by doctors, engineers and schoolmasters. With roads, railways and the telegraph, communications were improved, which was advantageous for the development of mines and plantations. The population of Malaya grew from half a million in 1850 to four million in 1931 as a result of improved health care, but also as a result of numerous immigrants from China, India and Ceylon.

The British attempted to maintain their own style of living. In Kuala Lumpur the first British club appeared, and cricket was

Below: A colonial bungalow in Penang.

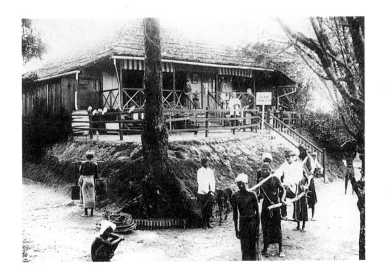

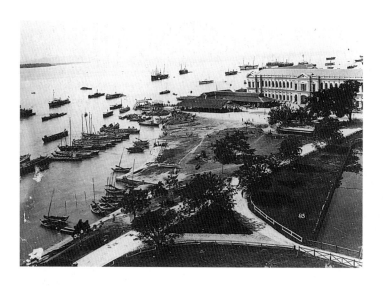

Above: The harbour of Penang in
about 1910.

played and tea was drunk. There were constant complaints about
the shortage of British women. There was still a taboo on marry-
ing Chinese or Malay girls, although some individuals went ahead
anyway, such as a Percy Bulbrook who married a Chinese girl and
wrote his superiors that they could go to hell; it was his private
life, he was in their service but his wife wasn't.

Rubber

The British introduced agriculture and forestry for the European
market. Until the middle of the nineteenth century, the main agri-
cultural products were pepper and nutmeg. From about 1849
sugar became important until contract labour was abolished in
1910. In about 1880 coffee was introduced by planters from
Ceylon. But the most spectacular product was rubber. At the ini-
tiative of Sir Joseph Hooker, director of the botanical gardens in
Kew, an expedition was sent to the Amazon in 1876, which
sought the *Hevea Brasiliensis*, the rubber tree. The expedition
returned with a large quantity of seeds which were planted in
greenhouses in Kew. Three thousand seedlings then went to the
British colonies, mainly to Ceylon. In 1877 some of these
Ceylonese plants arrived at the botanical gardens of Singapore.
The planters did not have much interest in this novelty in spite of
the enthusiasm of Henry Ridley, the director of the botanical gar-
dens, who was always walking about with tins of seeds in wet
charcoal which he was always giving away to planters. A few

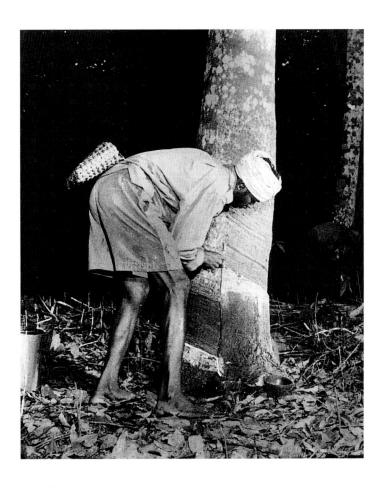

Above: A rubber tapper at work.

planters planted rubber trees in their coffee plantations as a pro-
tection against sun and wind. In the meantime Ridley developed a
method of rubber tapping which had a good yield while the trees
were not damaged. Around 1910 the situation changed complete-
ly. The coffee market crashed and Dunlop's invention of the
inflatable rubber tire, along with the expansion of the automobile
industry, increased the demand for rubber enormously. In around
1920 Malaya produced 200,000 tons a year, which was half of
world production. By this time, rubber was Malaya's second
export commodity after tin. The economic base of Malaya was fur-
ther broadened with the introduction of large scale planting of oil
palm, imported from West Africa in 1875. Although this tree was
commercially exploited from 1917 onwards, it was not until the
thirties that it became important as a result of increased demand
from, among others, the margarine industry.

The White Raja of Sarawak

The Anglo-Dutch treaty of 1824 did not mention Borneo at all. The largest part of the island, Kalimantan, came under the control of the Dutch. However, neither the Dutch, nor the British colonial authorities paid special attention to the northern part of the island. It became the location of some unusual private enterprise and adventure. The nominal ruler of the northern Borneo coast was the Malay Sultan of Brunei, but in reality most parts were the domain of tribes of headhunters and pirates: the Dayaks.

The most northern part of the island, now the state of Sabah, was ceded to a private concern called the British North Borneo Company, led by Alfred Dent who paid the Sultan of Brunei an annual commission. Although this territory became a British protectorate in 1881, the company ruled it independently from London until the second world war.

Even more extraordinary were the events in Sarawak after the arrival of James Brooke in 1839. Born in India in 1803, Brooke was attracted to Borneo and negotiated with the sultan the control over an area around the Sarawak River in exchange for a yearly payment. Brooke also promised to bring the Dayaks under his

Below: James Brooke's flagship, the *Dido*.

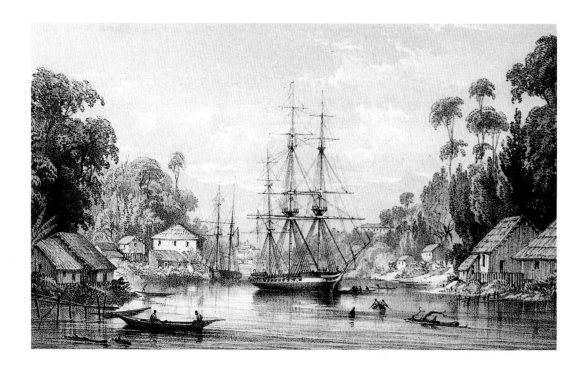

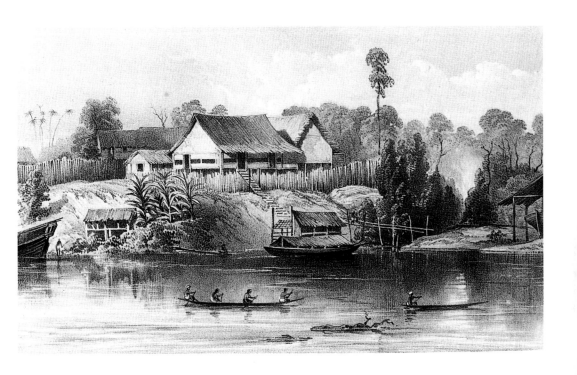

control. The sultan was only too glad to be rid of a part of his difficult realm.

Above: James Brooke's house in Kuching.

In 1841 Brooke adopted the title of Raja of Sarawak and commenced building the town of Kuching at the mouth of the Sarawak River. He became a ruler who administered his realm with a firm hand. The Dayaks — especially those living near the rivers and coast, the Iban — were fierce warriors, but Brooke was able to win many of them over and subjugated rebellious rulers. Gradually Brooke increased his territory by conquering river after river, and increasing his payments to the sultan accordingly. Brooke's relations with London were informal. In 1846 the British communicated to the Dutch, who were quite upset about the state of affairs in Borneo, that the British had no colonization plans at present but reserved the right to colonize. Brooke maintained his independence by refusing financial aid from London and he kept British trading posts out of Sarawak.

James Brooke died in 1868 and his title was passed to his nephew, Charles Brooke, who became the second white Raja of Sarawak. Raja Charles was more open to the outside world than his pioneer uncle, and he paid more attention to the development of Sarawak by admitting more businesses to the territory. Charles

Brooke died in 1917 and was succeeded by his son, Vyner Brooke, who ruled as third Raja of Sarawak until the outbreak of the Second World War.

Sarawak in the time of the White Rajas

Raja James Brooke and his successor Charles were both attracted to the native population of Borneo, which consisted of many different tribes of Dayaks. During a period of some four hundred years, these Dayaks had moved from South-east Borneo to what is now Sarawak. They moved, searching for land that could be deforested and levelled for dry rice cultivation. When the land was exhausted, they moved on. A tribe's experiences were carefully recorded in family chronicles which sometimes covered generations. Dayak tribes named themselves after the river on which they settled. They lived in longhouses, which could be up to 250 metres long and consisted of a series of elevated chambers with a common gallery. Dayak religion was animist; priests interceded with spirits through dreams or animal cries. There was much rivalry between the various tribes which led to endless struggles and wars, during which the taking of conquered enemies' heads as trophies was common practice. Human heads also had an

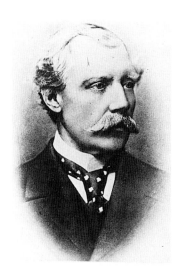

Above: Charles Brooke, the second white Raja of Sarawak.

Below: Sea Dayaks at Lundu in Sarawak.

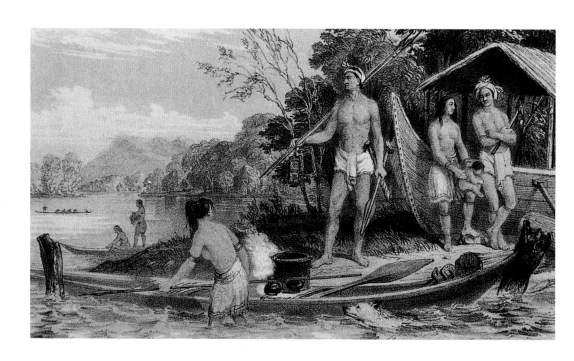

important ceremonial value, for instance for a warrior's wedding ceremony. Prisoners would be enslaved. In 1840 James Brooke was greatly embarrassed when he was presented with a little boy who had been taken prisoner. He wrote that the gift confused him; he did not know what to do with him and hesitated to accept the responsibility. After vainly searching for the boy's parents, Brooke decided to take in the boy and give him a Christian upbringing.

The Dayaks lived according to their own common law, and were governed reasonably democratically; there was no strict hierarchy and a man could rise through valour or eloquence. Large Chinese jugs, taken from merchant ships travelling on the South China Sea, were symbols of prosperity and an important means of exchange. The Brookes made good use of the warlike Iban in consolidating the hold on their territory.

Below: War dance of the Iban.

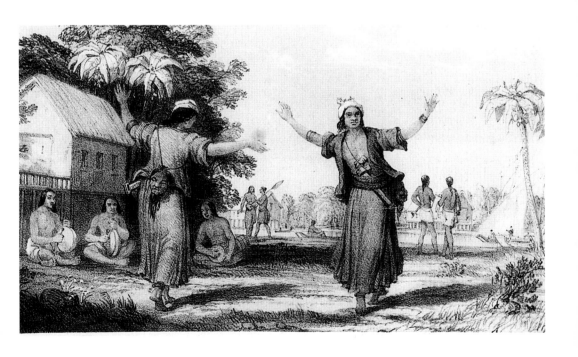

Malaysia on the road to independence

The Federation

The administrative structure set up by the British had many weaknesses. As early as the twenties it was realized that it was mainly an economic entity dealing with the tin mines and rubber plantations and had few benefits for the population. Also, the position of the sultans was unclear. They had little say over their own territories or federation affairs — traditionally the dignity of sultans did not allow involvement in politics. It was only with great difficulty that the British succeeded in positioning advisers in the northern states. The purpose of that was mainly to curb the influence of Siam. The position of Johore, still ruled by the descendants of the *temenggong* with whom Raffles had concluded his treaty, was totally different because of the proximity of Singapore. Abu Bakar, who bore the ancient title of Maharajah, had drawn up a constitution allowing the establishment of advisory bodies in 1895 with the help of British legal experts. Gradually these bodies acquired British members. Thus, on the eve of the outbreak of the Second World War, Malaya consisted of the FMS, the federation of four states with a mainly British government with its capital at Kuala Lumpur; the 'unfederated Malay states', of which Johore had the closest relations with the British and finally the British colonies of Singapore, Penang and Malacca, all three administered from Singapore. As a result of this extraordinary state of affairs there was less nationalist and anti-colonial sentiment among the population than in many other Asian nations.

Left: The *Ubudiah* mosque in Kuala Kangsar, Perak, built in 1913.

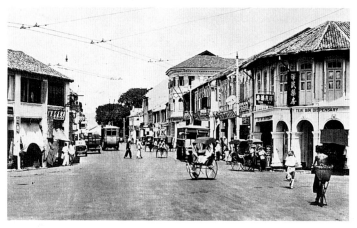

Top: Malacca in about 1900, with bullock cart crossing the bridge over the Malacca River. To the left, the Christ Church can be seen. Partly hidden by the big tree in the middle, is the old Dutch *Stadthuys*.

Above: Rickshaws and trolley busses in Georgetown, Penang, 1932.

The Japanese Occupation

On December 8, 1941, a day after the attack on the American fleet at Pearl Harbour, the Japanese invaded Malaya in the north. The British were quickly overwhelmed by this land attack — for centuries they had concentrated on defending themselves against seaborne invasion and the big guns of Singapore all pointed out to sea. The British army was not up to strength. The well-trained Japanese troops quickly advanced through the jungle to Singapore. British fleet units were sunk at sea by Japanese air attacks. On February 15, 1942 Singapore surrendered and Malaya came under Japanese occupation.

The Japanese cleverly played the various parts of the population against each other. The Europeans were humiliated, the Chinese persecuted, the Indians were put to work on the Burma railway line — for the time being the Malays were spared. The Japanese

attempted to administer both Malaya and Sumatra from Singapore. This had catastrophic consequences. Exports stopped and rice deliveries declined, which led to poverty, hunger and sickness. Epidemics broke out, the various segments of the population distrusted each other, and city dwellers fled to the countryside in the hope of finding food. Jungle commandos were formed, mainly under Communist leadership, and consisted of Chinese refugees. Their hit and run tactics caused the Japanese much damage.

The United Malays National Organisation (UMNO)

The abrupt end of the war after the nuclear bombing of Hiroshima and Nagasaki left Malaya in a vacuum. The guerillas hesitantly came out of the jungle, and large groups of people travelled around aimlessly. Theft and robbery were common as a result of the lack of government. Soon the first British returned,

Below: The government building in Kuala Lumpur in the 1950s. The building would later be renamed Sultan Abdul Samad Building, after the Sultan of Selangor, and now houses the Malaysian High Court.

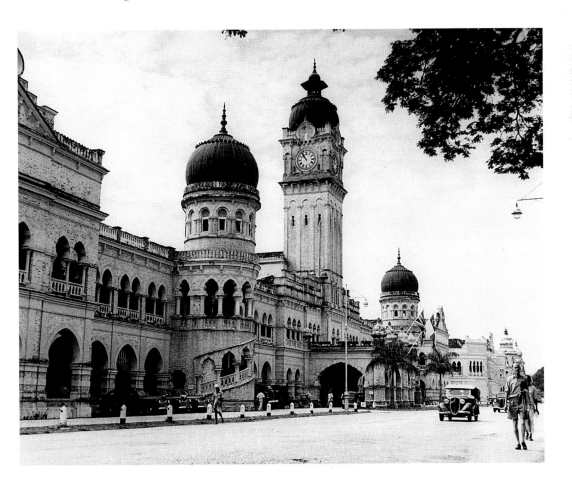

determined to quickly restore prewar conditions and also to
incorporate the states that had not joined the federation before
the war. The sultans were overwhelmed by hasty plans for a
Malay Union, incorporating all states of the peninsula. These
plans caused a storm of protest, particularly from the United
Malays National Organisation (UMNO), the powerful Malay political
party established in 1946. The British had to revoke their plans
and instead, in 1948, set up a federation of all Malay states, with
the exception of Singapore which remained a crown colony.
The British did not realize, like the other western powers, that the
Second World War and the period immediately preceding it had
radically changed thinking in Asia. Anti-colonialism erupted in the
old colonies, from time to time in the form of assassination
attempts and raids. On June 18, 1948 a state of emergency was
declared in Malaya, due to the continuing threat from Communist
guerrillas operating from the jungle. Mine owners and planters
joined forces and organized kampong guards. In 1950, General
Briggs, the British High Commissioner, took a number of radical
measures. He decided to create new kampongs where the many
people who had been displaced could settle. The food deliveries
to these kampongs were subject to strict control so that the
guerillas lost their source of supplies. Villages that continued sup-
plying the guerrillas were collectively punished. In the meantim,e

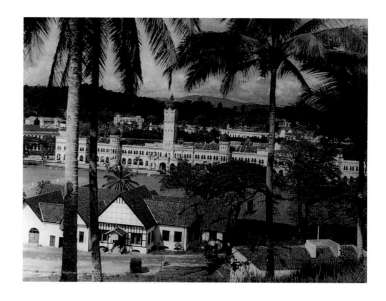

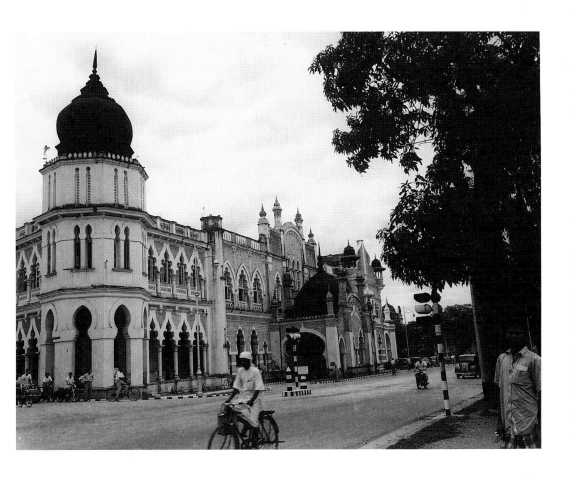

a local political structure emerged, including parties from the various population groups. Apart from UMNO, there was the MCA (Malayan Chinese Association) and the MIC (Malayan Indian Congress), and various other parties. The MCA offered the Chinese in Malaya a more realistic option than the communists, greatly improved the lot of the inhabitants of the 'new kampongs' by organizing lotteries, the profits of which went to education and health care. In 1952 an alliance was formed by UMNO, the MCA and the MIC, with the main purpose of gaining independence. The first federal elections of 1955, were won by the alliance in a landslide victory, with 51 of 52 seats.

Above: The former townhall of Kuala Lumpur.

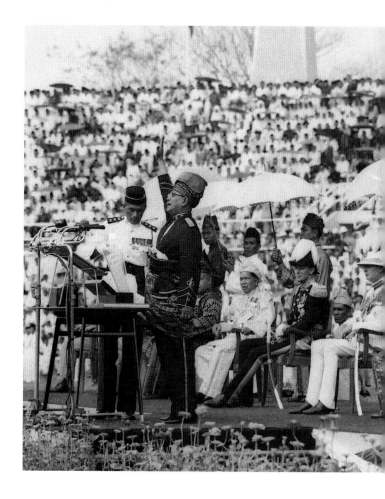

Independence

Following the alliance's election victory, a commission was
formed to draw up a constitution for an independent Malaya. This
constitution included a clause that every five years the sultans
would elect one of their own *Yang Di Pertuan Agong*, a king of
the whole country. The Conference of Rulers was retained, how-
ever, the power of the executive would be held by a democrati-
cally elected cabinet of ministers, headed by a prime-minister.
Although Islam became the country's official religion, the consti-
tution guaranteed freedom of faith to non-Muslims. Malay would
become the official language. The new constitution was ratified
on August 15, 1957, and on August 30, 1957, at midnight, a large
crowd on the padang in Kuala Lumpur saw the British flag low-
ered for the last time. The next day in the full Merdeka Stadium
the Duke of Gloucester transferred sovereignty in the name of the

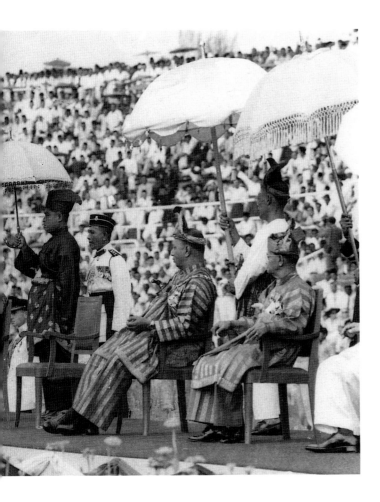

British Queen to Tungku Abdul Rahman, Malaya's first prime-minister. The transition to independence was peaceful, and exceptional since elsewhere in Asia, as in Indonesia, such transitions were generally accompanied by much violence and bloodshed.

Malaysia

The national alliance (better-known under its Malay name *Barisan Nasional)* of UMNO, MCA and MIC was strengthened by its major victory in the elections held two years after independence. Initially, Singapore did not become part of the newly independent country, but remained under British control. Also, the British territories on Borneo, Sarawak and Sabah (formely British North Borneo), were still under colonial government. Vyner Brooke, the third white Raja of Sarawak returned briefly after the war, but in July 1946 both Sarawak and Sabah became British crown colonies.

In 1961 the formation of a 'greater Malaysia', incorporating the states of the peninsula, Singapore, Sarawak and Sabah, was proposed by UMNO. Thus, in 1963, the federation of Malaysia was formed. However, Singapore left again in 1965 to become an independent republic. Malaysia now consists of thirteen states: eleven on the Malay peninsula and two in northern Borneo. Upon the transition to independence, Malaysia was suddenly on its own. While the British government followed developments with great interest and declared itself ready to intervene on behalf of its old colony in case of external threats, the inhabitants of the Peninsula experienced that they were no longer part of a British colony inhabited by Asians, but part of a richly varied population.

One of the charming aspects of Malaysia is its diverse population. It includes the *bumiputras* ('sons of the soil'), a term which refers to all members of the indigenous South-east Asian races are meant. Apart from the Malays, these are the *orang asli* ('original people'), the peninsula's jungle dwellers who have retained their own culture in isolation, and also the indigenous population groups in Sarawak and Sabah, such as the Iban, the Melanau, the Kadazan, the Bajau and the Murut. Then there are the Chinese, partly the descendants of those who settled long ago in Malacca and Penang, and who have developed a unique hybrid 'Straits

Below: A Malayan Airways aircraft refueling at Kota Bharu.

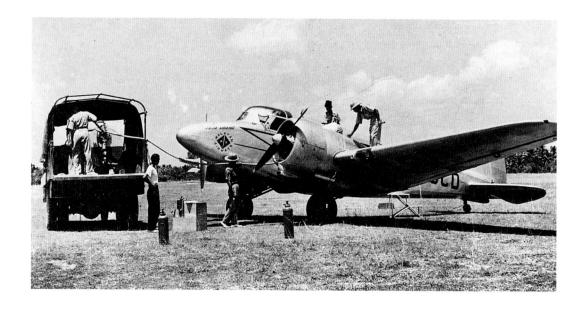

Chinese', or *baba*, culture. Other Chinese are descendants of farmers, miners and tradespeople, who came in large numbers during the 19th century. The third largest group are the Indians, mainly Tamils, including both Hindus and Muslims. Finally there are the descendants of the Europeans, including the remarkable Portuguese community in Malacca.

The government strove to maintain the balance between the various segments of the population, and to achieve an even distribution of the nation's wealth to build a strong basis for unity. To this end various economic policies and programmes were started. One of such programmes was, for example, the FELDA (Federal Land Development Authority) projects by means of which many farmers, especially in Pahang and Johore, received land ownership.

As politics in South-east Asia stabilised and the economy grew, relations between Asian countries improved to the point that in 1967 the ASEAN (Association of South-east Asian Nations) was founded, which envisaged close cooperation between Malaysia, Indonesia, Singapore, Brunei, Thailand and the Philippines.

In recent decades Malaysia has developed into a self-confident nation. Industries based on natural resources such as tin, rubber, timber and palm oil have remained important. However, especially after the recession of the eighties, the economy has been diversified.

Malaysia is an attractive place for business because of a strongly improved education system, relatively low taxes and a favourable location. This has attracted many large international corporations to establish plants, and locally owned industry has gained strength at a steady pace. In the late 1980s and 1990s, Malaysia's economy has been one of the most rapidly growing in the world.

Barisan Nasional — now including several other political parties, also from Sarawak and Sabah — has remained in power since independence, and has been planning well into the 21st century to improve the prosperity of Malaysia. The last few years tourism has increasingly been promoted, exploiting the country's unique features. Malaysia offers natural beauty with an extraordinary variation in animal and plant life as well as a rich culture, including very diverse Asian ethnic groups, brought together by history in this country on the divide between the monsoons.

Above: The rapidly changing skyline of Kuala Lumpur with, on the left, the present headquarters of Malaysia Airlines.

Picture credits